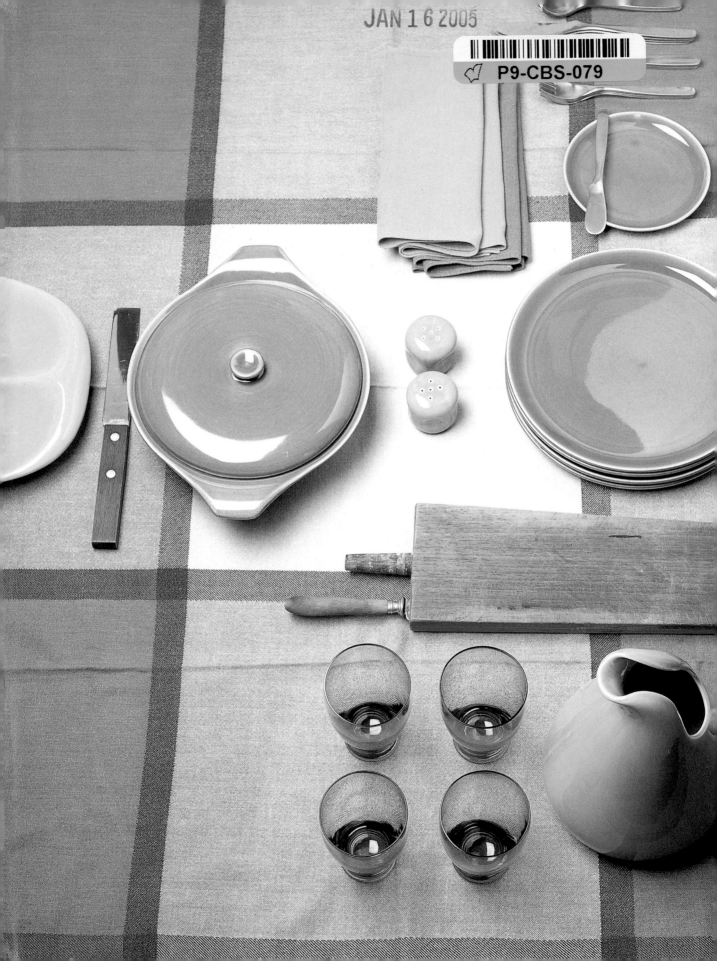

RUSSEL WRIGHT				
			NEW YORK CITY	
CLIENT				
ITEM				
	No	Date	Drawn By	Approved By
DRAWING	12	9-46		
SCALE				
REVISIONS				

THIS DRAWING IS THE PROPERTY OF RUSSEL WRIGHT AND IS AN
INSTRUMENT OF SERVICE ITS USE FOR ANY OTHER PURPOSE
EXCEPT BY AGREEMENT OR SPECIAL AUTHORIZATION IS FORBIDDEN.

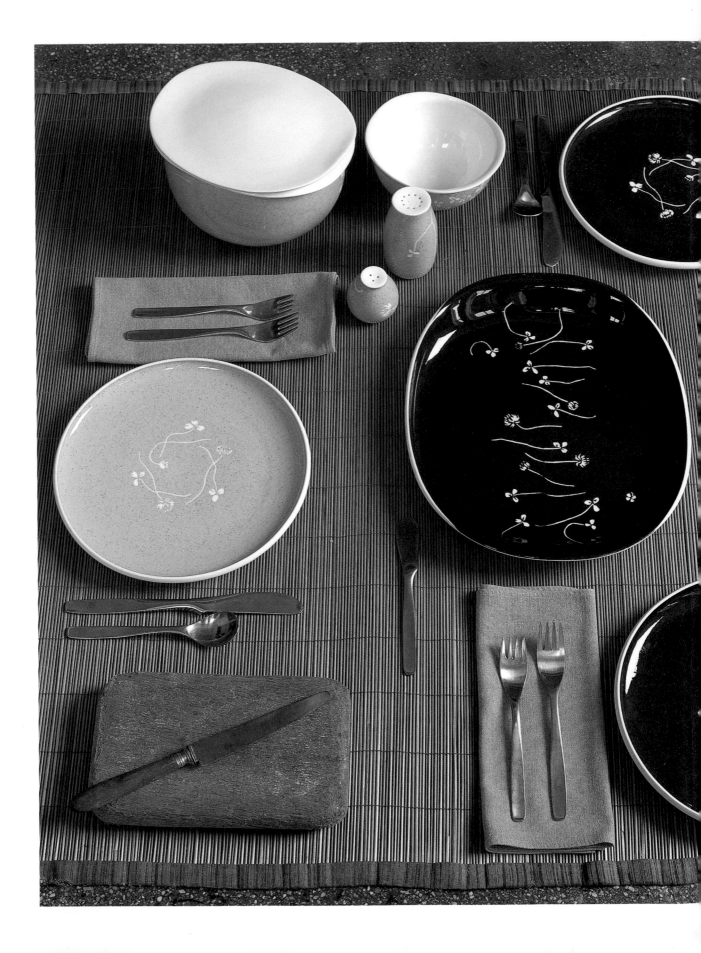

RUSSEL WRIGHT
creating american lifestyle

donald albrecht | robert schonfeld | lindsay stamm shapiro

cooper-hewitt, national design museum, smithsonian institution

harry n. abrams, inc., new york

Published in conjunction with the exhibition Russel Wright: Creating American Lifestyle at Cooper-Hewitt, National Design Museum, Smithsonian Institution, New York, November 20, 2001–March 10, 2002.

Editor: Elizabeth Johnson
Book design: J. Abbott Miller and Jeremy Hoffman, Pentagram

Library of Congress Cataloging-in-Publication Data
Albrecht, Donald.
Russel Wright : creating American lifestyle / Donald Albrecht, Robert Schonfeld, Lindsay Stamm Shapiro.
p. cm.
Catalog of an exhibition at Cooper-Hewitt National Design Museum, New York.
Includes bibliographical references and index.
ISBN 0-8109-3278-4
1. Wright, Russel, 1904–1976—Exhibitions. I. Schonfeld, Robert. II. Shapiro, Lindsay Stamm. III. Cooper-Hewitt Museum. IV. Title.
NK1412.W75 A4 2001
745.4'492—dc21 2001002513

Published in 2001 by Harry N. Abrams, Incorporated, New York

Printed and bound in Hong Kong
10 9 8 7 6 5 4 3 2 1

Harry N. Abrams, Inc.
100 Fifth Avenue
New York, N.Y. 10011
www.abramsbooks.com

Front endpapers: American Modern dinnerware, 1939; American Modern tumblers, 1951; Highlight/Pinch flatware, 1951; serving fork and knife, date unknown; tablecloth and matkins, 1950 (see pages 80–81). Photo: Anita Calero

Back endpapers and title page: White Clover dinnerware, 1951; American Modern tumblers, 1951; Highlight/Pinch flatware, 1951; Matkins, 1950 (see pages 74–75). Photo: Anita Calero

Frontispiece: Title block detail from sketch of Kosta glassware (not produced), 1946. Courtesy Russel Wright Department of Special Collections, Syracuse University Library. Photo: Matt Flynn

FOREWORD

Russel Wright was one of America's great industrial designers. By devoting much of his career to creating beautiful, functional, and affordable designs for the home, Wright enhanced daily life for millions of Americans—a cause long championed by Cooper-Hewitt, National Design Museum, Smithsonian Institution. His inexpensive, mass-produced dinnerware, appliances, furniture, and textiles introduced modernism to millions of American households between 1930 and the mid-1960s. In addition to designing objects that were visually and technically innovative, Wright also pioneered the concept of "easier living" for the middle class. By creating lifestyle, and not just a series of objects, Wright presaged many of today's design issues, including the psychology of design, user experience, and the importance of marketing.

Designers today are increasingly interested in reaching beyond function to emotion—an interest that finds an early proponent in the work of Russel Wright. Wright began his career as a designer in theater in the 1920s, and his background informed his work when he moved into industrial design a few years later. He saw the dinner table as the ritualistic stage for a daily drama and created designs intended to evoke a specific mood. As Wright expanded into interior design and eventually land-scape design, ceremonies and moods remained constant themes. In 1950, he and his wife, Mary, published *Guide to Easier Living*, a comprehensive manual that scripted the rituals, both large and small, of modern daily life. From the size and shape of rooms for ideal family living to setting the table for guests' maximum enjoyment, *Guide* advised homeowners on how to set the stage to elicit emotional responses.

Wright's ability to anticipate the ways in which the objects he designed would be consumed set him apart from designers concentrated primarily on the aesthetics of the object. Creating dinnerware that could go directly from stove to table or could be used for serving different items in different settings, he designed for efficiency and economy—two core American values strengthened by the machine age and war effort.

Russel Wright was one of the first American designers to become a household name. His iconic American Modern dinnerware line, introduced in 1939, was one of the

century's best-selling designs. By mass-producing all of his furnishings at low prices, Wright made modernism accessible to the widest possible audience. With the invaluable help of Mary, Russel Wright seized the dawning of the grand age of advertising and marketed himself and his products on a new scale.

I am delighted to present this timely book and the exhibition it accompanies at Cooper-Hewitt, National Design Museum. Donald Albrecht and Robert Schonfeld, co-curators of the exhibition, and their coauthor, Lindsay Stamm Shapiro, examine Wright's work as a design revolution in the American home. Their work would have been impossible without the support of various individuals, corporations, and institutions. We are grateful to all our sponsors, especially Marilyn Simons for her early support and the Andrew W. Mellon Foundation Endowment for their support of this book.

Paul Warwick Thompson
Director
Cooper-Hewitt, National Design Museum,
Smithsonian Institution

ACKNOWLEDGMENTS

Russel Wright: Creating American Lifestyle has been developed over many years, so we need to express our gratitude to numerous invaluable people. Collectors form the backbone of any exhibition project and for their help on this catalogue, we acknowledge the insights and efforts of Charles Alexander and Dennis J. Mykytyn as well as those of Tom O'Brien, Michael Pratt, John A. Shriver, McKinley Williams, and Jaye Zimet. Terrance Keenan has long been helpful in our research efforts in the archives of Russel Wright at Syracuse University. At Cooper-Hewitt, National Museum, we especially want to thank our coauthor, Lindsay Stamm Shapiro, for her excellent essay. Museum director Paul Thompson avidly supported the project even before he assumed his position, and his efforts since then have proved vital. Susan Yelavich was a valuable sounding board for ideas throughout a long process. Jill Bloomer oversaw the production of new photography for this book. Dorothy Dunn, Jennifer Brundage, Monica Hampton, Mei Mah, and Lisa Mazzola of the education department conceived stimulating programs. The exhibition's graphic design and installation was creatively conceived and implemented by Linda Branning and Yve Ludwig of the design department, headed by Alicia Cheng and Jen Roos. Architect Sandra Wheeler designed an elegant installation, dramatically lit by Anita Jorgensen. The production and management of the exhibition was led by Lindsay Stamm Shapiro with Jocelyn Groom and Scott Wilhelme. Essential support for this project was also provided by Laurie Bodor, Ina Sorens Clark, Linda Dunne, Missy Falkenberg, Kris Herndon, Steven Langehough, Annie LaRock, Jeff McCartney, Todd Olson, and Deborah Shinn.

Russel and Mary Wright's daughter, Ann, was a constant supporter and provided a unique perspective on life with Russel Wright. We also thank Bill Burback, Joe Chapman, Anne E. Impellizzeri, David Leavitt, Eugene Morgenthau, Irving Richards, and Margaret Spader. Carol Franklin of Andropogon Associates, Ltd., was generous in aiding our understanding of Wright's intentions in his landscape design at Manitoga.

At Harry N. Abrams, Eric Himmel was an astute reader and an idea collaborator. We especially thank J. Abbott Miller and Jeremy Hoffman of Pentagram for the book's

thoughtful and visually striking design. We greatly appreciate the efforts of three expert photographers: Anita Calero, who created the wonderful table settings in the book, and Matt Flynn and Chris Day, whose shots reveal the beauty of Wright's work.

Kristina Kaufman supported us with her expert research skills and capacity to handle myriad details. Natalie Shivers was instrumental in shaping and improving "From Hollywood to Walden Pond." Robert Schonfeld's work on Russel Wright, including this book, would not have been possible without the unwavering support, insight, and indulgence of Mazal Schonfeld. Donald Albrecht values the contributions of his friends and family, especially his mother. Finally, special thanks is due to the Museum's editor, Elizabeth Johnson, who was an advocate of clarity and comprehensiveness. This book would not be what it is without her efforts.

Donald Albrecht and Robert Schonfeld, co-curators,
Russel Wright: Creating American Lifestyle

This book dates dinnerware lines by the year of initial manufacture. For information on the subsequent introduction of new colors and pieces, the authors recommend consulting the collectors' guides by Ann Kerr and Joe Keller & David Ross listed in the bibliography.

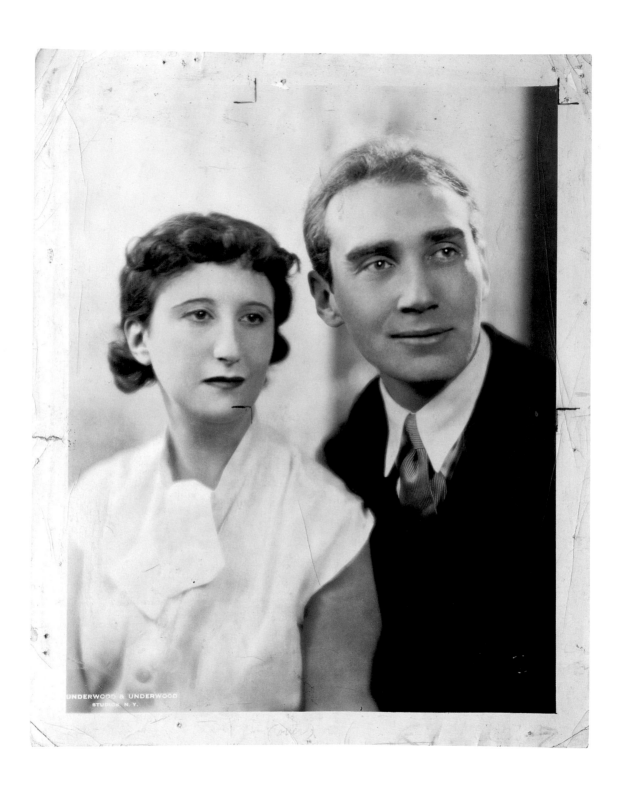

Mary and Russel Wright, ca. 1930

INTRODUCTION

Donald Albrecht and Robert Schonfeld

"Do our homes really express the ideals of democracy and individualism we all profess?" Russel and Mary Wright asked this question at the beginning of their landmark 1950 book, Guide to Easier Living, but they had been steadily answering it for almost two decades through their work.[1] Striving for an egalitarian ideal of high-quality, modern design for all, the Wrights revolutionized the American home and the way people lived there. Russel's inexpensive, mass-produced dinnerware, furniture, appliances, and textiles were not only visually and technically innovative, but were also the tools to achieve the Wrights' concept of "easier living"—a uniquely American lifestyle that was gracious yet contemporary and informal.

Russel Wright conceived the domestic environment broadly, working in layers from the very core of home life—the table—outward toward furnishings, interiors, architecture, and landscape. The Wrights disseminated their designs and ideas in exhibitions, books, articles, advertisements, radio interviews, and demonstration rooms in department stores.[2] In all these enterprises, Russel and Mary Wright converted his name and signature into a recognizable trademark on a par with major manufacturers. They invented lifestyle marketing centered on a compelling persona, paving the way for such lifestyle interpreters as Martha Stewart and Ralph Lauren. Acknowledging Wright's role as an influential tastemaker, noted designer George Nelson called Wright the person most responsible for "the shift in taste toward modern in the late 1930s."[3]

The man behind the name was born in Lebanon, Ohio, in 1904. His maternal lineage traced back to two signers of the Declaration of Independence—a heritage that Wright would draw on throughout his career as he modernized early American

values for the twentieth century.[4] Equally influential was his father's side of the family. Russel would carry forward his paternal grandfather's Quakerism in his continuous search for functional objects designed without superfluous style, as well as his family's progressive social advocacy of such causes as the Underground Railroad and the temperance movement, still living memories when he was growing up. Wright would later adapt this evangelizing background to the cultural tenor of the Depression, when the social purpose of art gained new force. In the 1930s Russel and other leading designers such as Raymond Loewy and Henry Dreyfuss linked art and industry in an effort to revive the economy and improve people's everyday lives.[5]

Wright had studied art from the age of ten, eventually taking classes at the Cincinnati Academy of Art and graduating early from high school at age sixteen. To please his father, a judge, Wright had agreed to prepare for a career in law at Princeton University, but his father felt he should take a year off before beginning college. Russel used this time to attend the Art Students League in New York City in 1920–21. Observing Russel's technique there, his painting teacher Kenneth Hayes Miller noted with displeasure that he was not painting on the canvas, he was "carving it."[6] He advised Russel to study sculpture—an essential transition to the world of three-dimensional design.

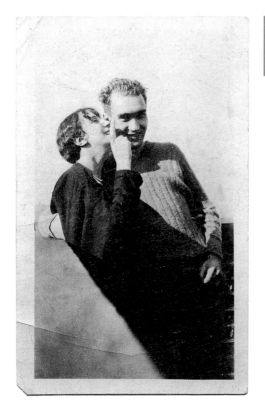

Russel Wright and friend, possibly Aline Bernstein, ca. 1920

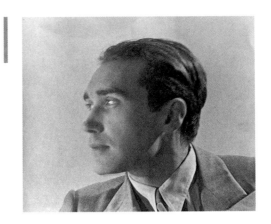

Russel Wright,
1920s

At Princeton in 1921–22 Russel was unenthusiastic about his classes, and he took refuge by working in school plays, which would eventually be the launching pad for his design career. He soon joined the artistically oriented Triangle Club, for which he designed and executed scenery, as well as the Theatre Intime, a student art theater. For Wright, Princeton's only other advantage was its proximity to New York, where he ventured to attend the theater on weekends and apprenticed himself, free of charge, to the celebrated set designer Norman Bel Geddes on Max Reinhardt's lavish production of The Miracle. (Like Wright, Bel Geddes in the 1930s would transform a career in the theater into one in the new field of industrial design.) During the summer after his sophomore year, Wright designed props for the Maverick Art Colony in Woodstock, New York. Enticed by the professional theater, he dropped out of college in his junior year.

Russel struggled through many jobs, running errands for famous designers, trying to interest celebrities and producers in his ideas, and stage-managing plays. Eventually, he landed a position as designer for George Cukor's company in Rochester, New York. The experience of overseeing construction of sets and props, which would be his last in the theater, nevertheless prepared him for the similar process of industrial design. Exhausted by the grueling schedule and nearly broke to boot, Wright returned to New York City in 1929.

Whereas Wright's biological family shaped his nonconformism and sense of social advocacy, his theater family taught equally valuable lessons for a life in design. Wright credited his first and most important mentor, the costume designer Aline Bernstein, for teaching him the "concept of doing a small job perfectly." At the same time, he remembered the impresario Bel Geddes as one who "always thought in terms of large scale projects."[7] For the rest of his career—from finding the perfectly curved handle to masterminding the operatic landscape of Manitoga—Wright balanced these forces in his work.

Wright might have stayed in regional theater had he not met Mary Small Einstein in Woodstock, New York. Born in 1905 in New York City, Mary, whom he married in 1927, would bring to their partnership a genius for marketing and promotion, inherited from her family of successful textile manufacturers and merchants. (The family was distinguished in other ways as well; her grandfather's cousin was physicist Albert Einstein.) When she met Russel, Mary was studying sculpture with avant-garde artist Alexander Archipenko.[8] Russel would later translate smooth, dynamic forms reminiscent of Archipenko's style, seen in the sculptor's bust of Mary, into his revolutionary American Modern dinnerware. Throughout her collaboration with Russel, Mary devoted her energies to co-conceiving the "easier living" lifestyle and packaging it for the public, ensuring that the dinnerware reached the American table. She critiqued Russel's designs and generated themed presentations to market them, gave radio interviews, and made in-store appearances. She wrote advertising copy and invented names for lines of tableware and furnishings. She even found time to design her own line of dinnerware.

It was Mary who propelled Wright into the field of industrial design. Upon their move to New York City in 1929, she persuaded him to create objects to be sold in fashionable Madison Avenue shops, and for the rest of his life, no matter what else Russel did, he was first and foremost a designer of three-dimensional objects. Russel began by making life-size caricature masks of several contemporary celebrities: Greta Garbo in translucent plastic with spun-glass hair, Herbert Hoover in marshmallows, and John Barrymore in mirrored glass.[9] Although these failed to sell, a collection of decorative circus animals, cast in metal, opened the door to a glamorous world of New

Mary Einstein Wright,
artist unknown,
watercolor, pen, and
graphite on board,
1920s

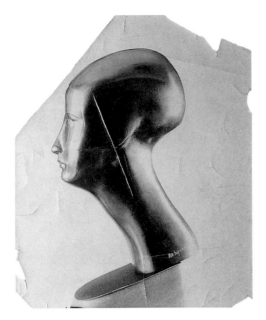 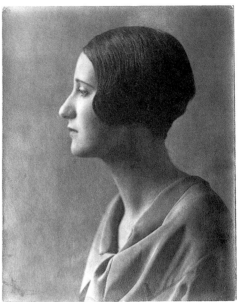

York celebrities and led to Russel's designs for mass-produced accessories in spun aluminum. Appearing around 1930, these were perfectly timed to appeal to the more informal taste of the urban upper middle class in the Depression.

Russel Wright's launch of his spun aluminum products coincided with the enthusiastic acceptance of modern design in America. Only five years earlier, Americans had been notably absent from the enormously influential Paris exhibition of 1925. Herbert Hoover, then Secretary of Commerce, declined the organizers' invitation to have American designers participate, saying that his country could not fulfill their stipulation that all items on display must be modern. Nevertheless Hoover sent a delegation of more than one hundred American manufacturers and artists to the fair after it opened, and thousands of American tourists visited the exposition's six-month run in Paris. A reduced version of the exhibition traveled the United States the next year and attracted large crowds.

Subsequently, modern design advanced in America on many fronts. Good Furniture magazine began to cover new trends in 1927 and in the following year openly advocated modern design by covering modern furniture demonstration rooms at two leading New York department stores, R. H. Macy's and

Bust of Mary Einstein Wright, Alexander Archipenko, 1920s

Mary Einstein Wright, 1920s

Mary and Russel,
1940s

Wanamaker's. Even the movies, from Our Dancing Daughters (1928) starring Joan Crawford to The Kiss (1929) starring Greta Garbo, adopted modernism to depict chic lifestyles.

America's movement to modernism was accelerated by the emergence of a field situated at the precarious intersection of art and commerce. Industrial design integrates analysis of a product's functional performance as well as the cohesive styling of a company's identity. It had been practiced as early as the 1900s, when Peter Behrens designed buildings, objects, and graphics for the German utility company AEG. The field emerged in the United States in the late 1920s and was given new impetus by the economic problems of the Depression, when manufacturers hired designers to stimulate their customers' interest by reformulating their products in new streamlined forms and modern materials. Because no formal schools in America were teaching industrial design, early practitioners often came from related fields, such as theater and store design.

When Russel Wright, a founding member of the industrial design profession, made the transition to this new field, he brought from the theater an ability to combine objects, lighting, and people to create a dramatic "moods" for modern living. He applied this holistic environmental approach throughout the rest of his career, working for large companies, such as General Electric, Samsonite, and DuPont, or small factories that were revived with his innovative products.

Wright modified his interpretation of the appropriate mood for modern life over the three decades of his career. The Informal Serving Accessories line in spun aluminum had been tailored to a sophisticated urban audience. Extending their

reach beyond machine-age aesthetics, the Wrights moved into the warmer palette of wood with Oceana, a series of serving accessories with organic forms—the first manifestation of Wright's ongoing interest in nature. Later they produced a line of simple wooden furniture for the middle class, inspired by the Colonial Revival and named American Modern, the brand name they applied to subsequent lines of dinnerware, glassware, cutlery, and even table linens. In the late 1930s Wright's invention of a new, distinctly American dinnerware—also named American Modern, with its bold shapes, earthy colors, and jewel-like glazes—would become the defining moment of his career.

For Wright the next logical step after creating integrated lines of dinnerware and accessories was to form a national network of designers, craftspeople, manufacturers, and retailers. Russel and Mary's American Way program, launched in 1940 at Macy's by First Lady Eleanor Roosevelt, had three goals: the mass-production of original designs by both well-known and unknown craftspeople and designers; the creation of a national distribution network for this merchandise; and a coordinated promotional campaign. The program aimed to "help rid this country of her great Art-Inferiority-Complex," which was part of a larger movement to define a distinctly American identity free from the design influences of Europe.[10] But Russel's attempt to emulate the grand vision of Norman Bel Geddes collapsed of its own weight.

Undeterred, the Wrights continued to generate ideas about the domestic environment through the war years and were ready to meet postwar demands for household goods. By scaling back to the market they knew, Russel and Mary built upon the design and marketing concepts they had perfected during the Depression. Concepts like

Russel and guest planning Easter party, 1956

stove-to-table ware; themed presentations; and open stock retailing, which allowed consumers to mix and match tableware to meet their specific needs, were powerful marketing tools in the booming Cold War economy. In 1946 the Wrights introduced Iroquois Casual China, an "unbreakable" rephrasing of American Modern ideals. In 1950 they published Guide to Easier Living, their manifesto on suburban domestic life. In contrast to simpler living, which would have implied only reduction or asceticism, easier living connoted effortlessness, spontaneity, and a relaxed attitude toward modern life.

The Wrights advised Americans to live in ways that were practical, elegant, and free from drudgery. They contrasted easier living with gracious living, an "Old Dream" that "suited our grandmothers.... [It saddles us] with a dictatorship of etiquette that stifles individuality."[11] The book tried to liberate readers from the stiff dinner party, the formal tea party, and fussy houses that "make scolds out of so many women, who are constantly after their families to keep coke bottles off the coffee table, feet off the sofa."[12] Using their own townhouse on 48th Street as a laboratory for Guide to Easier Living, they focused on the flexible, open-planned home as the ideal living space for returning veterans and their families, and advocated such ideas as outdoor living rooms, all-in-one family rooms, and freestanding, glass-fronted storage units that could serve as informal room dividers.

Toy doll American Modern coffee service, initially designed for Russel's daughter, Ann, plastic, ca. 1959

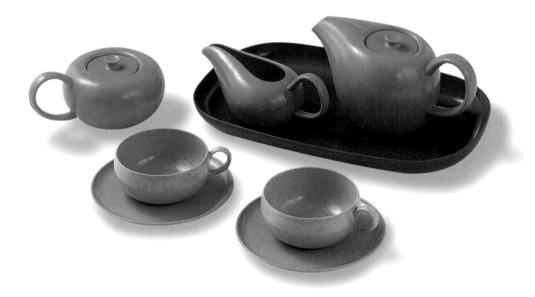

In doing so the Wrights helped to popularize the domestic architectural ideals of Frank Lloyd Wright, who had developed the open-plan Prairie House in the Midwest in the early decades of the century. In the 1930s he expanded his clientele to include forward-looking members of the middle-class in such houses as the Willey House outside Minneapolis and the Lloyd Lewis House near Chicago. Frank Lloyd Wright had thus established the template for Russel and Mary Wright's interpretation of modern living.

The Wrights also championed a "new hospitality" for young newlyweds who were moving away from cities and family connections into new suburbs among strangers. These homeowners needed to form social networks, and entertaining provided the key. The Wrights advocated the self-served buffet supper and casual patio living, urging their readers to invite friends and family into the kitchen to help cook as a fun, leisure-time activity. *Guide to Easier Living* culminated the Wrights' efforts to offer middle-class Americans compelling recipes for domesticity. More than their fellow modernists Charles and Ray Eames or George Nelson, the Wrights influenced the postwar home in an all-encompassing way.

With Mary's death in 1952 from breast cancer, Wright began the final chapter of his life. His 1950s designs for the home included such successes as plastic Residential dinnerware and a popular ceramic clock for General Electric. In the same period, he moved further toward decorative patterns in his dinnerware, first with the incised White Clover line in 1951, and then with a series of designs embellished with leaves, flowers, and other natural forms and covered in delicate glazes. In a new aesthetic climate of bolder, brighter colors presented in a pop, graphic way, Wright's ethereal palette distanced him from the design vanguard. By the 1960s the marketplace deserted him as well.

Nature, a preoccupation dating back to the Oceana line of the 1930s, now became the central theme of Wright's life. In 1942 Russel and Mary had purchased an abandoned quarry on eighty acres of land on the Hudson River outside New York City. As with all of Wright's revolutionary concepts, the beginnings of what would become his magnum opus—Dragon Rock and Manitoga—would be small steps in an

Russel at Manitoga
with his poodle Turk,
1972

evolutionary design process. The Wrights' small bungalow on the site was so closely
surrounded by woods that Russel slowly began to cut them back, exploring and expos-
ing interesting features: boulders, cliffs, ravines, giant trees, and river vistas. "The pro-
tective land…around our weekend places," Russel wrote of the lessons to be gleaned
from his weekend reclamation project, "can become a wonderland for your children, or
a revitalizing stroll for your guests."[13]

Throughout the 1950s Russel continued to expand his weekend retreat, building
a new house that he and Ann, the daughter he and Mary had adopted, moved into
around 1961. (Russel would later relocate there permanently after closing his office in
the city.) Dragon Rock, the name Ann gave the house, was a wood, stone, and glass
structure tucked into the edge of the quarry.[14] Following his own manifesto, Wright
designed one of the most idiosyncratic homes in America.

Russel called the surrounding landscape Manitoga, from the Algonquian for "place
of the great spirit." He diverted a stream to fill the quarry and created eleven woodland
paths originating at the house, each themed, like a Wright table setting, according to
the time of day or season of the year. The paths were designed by Wright to become
more rugged as they moved away from the house, gradually immersing urban visitors
in nature. Expanding this concept to the public realm, Russel worked with the National
Park Service in the late 1960s, developing a program of concerts and events to bring
people into the parks of Washington, D.C. The year before his death from cancer in
1976, Wright announced the opening of Manitoga's trails to the public under the super-
vision of The Nature Conservancy—a generous gesture influenced by the burgeoning
environmental movement. "My goal," Russel wrote, echoing Thoreau, "is to bring to
American culture an intimacy with nature."[15]

This book, like the exhibition it accompanies, follows the path Russel Wright traveled in his career from a designer of tableware to an orchestrator of the natural environment. "A Man and His Manners: Resetting the American Table" interprets Wright's dinnerware and furnishings as expressions of the new informality that he and Mary promoted. In the spirit of the Wrights, for whom compelling photography was an essential promotional tool, Cooper-Hewitt, National Design Museum specially commissioned a collection of images for the conclusion of this essay. Anita Calero's photographs beautifully capture both the formal and the social dimensions of Russel and Mary's work, from individual objects to scripts for entertaining. "From Hollywood to Walden Pond: Stage Sets for American Living" views Russel's interior designs and architectural projects through the lens of his theater background. The photo essay "Manitoga: A Modern Landscape in the Hudson River Valley" situates Wright's masterpiece within the tradition of regional estates. Finally, considering the central role that marketing played in Wright's success, "Marketing Easier Living: The Commodification of Russel Wright" emphasizes the innovative ways Mary Wright and business partner Irving Richards promoted the Russel Wright brand.

Throughout, the book portrays Wright as a designer whose career embodied numerous contradictions. The Wrights saw the future through the lens of the past, and Russel married contemporary industrial methods with time-honored values of craftsmanship. They gave people detailed instructions on how to be improvisational. Mary devised highly successful marketing campaigns that included presenting herself as a mere housewife benefiting from her husband's designs. They wrote of how to achieve happiness in the suburbs while they themselves divided their time between Manhattan and the rural Hudson River Valley.

The ultimate contradiction, however, is embedded in the tradition of American progressive reformers, who have often mediated the opposing forces of expertise and individualism.[16] Russel and Mary Wright created a body of work that did indeed espouse the complex values of a democratic society. They negotiated the inherent paradox of dictating freedom of choice. They guided Americans on a path toward a new way of life, embedded in the nation's ideals.

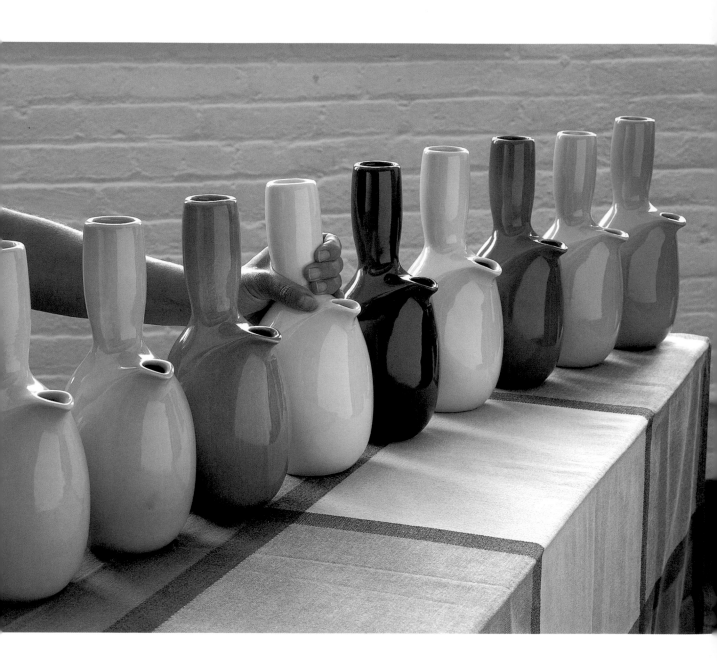

Iroquois Casual China carafes in assorted colors, whiteware, 1946

A MAN AND HIS MANNERS
resetting
the american table

Lindsay Stamm Shapiro

Russel Wright designed dinnerware, furnishings, and accessories characterized by a staggering visual variety but united by a constant search for a "new hospitality" rooted in American pragmatism.[1] In designing for the way people really lived, Russel and his wife, Mary, defined and equipped an intermediate world between the china of convention and the paper of the picnic.

Throughout their careers, Russel created and Mary promoted dinnerware and furniture tailored to the increasing informality of American lifestyle in the twentieth century. New lifestyles required new dishes, and the Wrights applied ingenuity and engineering to the task. They brought aluminum "out of the kitchen and into our living and dining rooms."[2] Stove-to-table casseroles and refrigerator-to-table utensils saved labor. Gravy boat lids doubled as saucers, and "matkins" were placemats that could also be napkins. Stackable sugar-and-creamer sets and salt-and-pepper shakers saved space on the table and in the cupboard. Furniture on casters could be moved from room to room. Armchairs featured built-in tables and magazine racks. Themed table settings made entertaining informal and invited guests to pitch in. While not all of these concepts were invented by the Wrights, they packaged and promoted these ideas in a way that was uniquely appealing to a progressive, style-conscious American public.

But the Wrights also saw the past in the future. In their landmark book, *Guide to Easier Living*, they paid homage to the American ideals of rational function and efficiency: "We deplore the passing of the American farm kitchen, with its massive dining table in the center…. That big table was the logical place for the family to dine. The hot biscuits were really hot out of the oven, the second helpings kept warm on the back of the stove, and Mother did not waste a step in setting, serving, or clearing."[3]

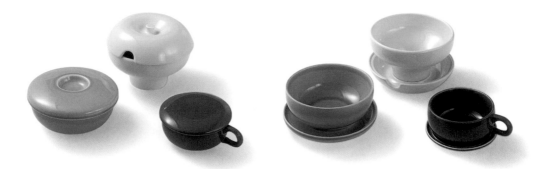

In their search for efficiency, the Wrights were part of their time. In the early twentieth century several factors revolutionized American food preparation and eating habits. Home economists persuaded Americans to eat simpler meals with fewer courses, fewer ingredients, and less preparation.[4] As women entered the workplace in unprecedented numbers in the early decades of the century, fewer of them worked as housekeepers and cooks. At the same time, electric appliances, prepared foods, and plastic were introduced to the home, as were time-and-motion studies from industry.

Preeminent in this field was the work of Frank and Lillian Gilbreth, who had applied the efficiency of the automotive assembly line to the office and home. (The inspiration for all their work was Frederick Winslow Taylor's 1911 book, *Principles of Scientific Management*.) After Frank's death in 1924, Lillian was commissioned by the Brooklyn Gas Company to produce "Efficiency Methods Applied to Kitchen Design," a study that proposed reducing the number of kitchen operations by rearranging its equipment.[5]

Mary and Russel Wright methodically studied such analyses of the American kitchen and dining habits. In a chapter of *Guide to Easier Living* called "The Housewife-Engineer," they urged their readers to apply this research to their own homes and to perform their own time-and-motion studies on household tasks, such as peeling potatoes, making beds, and housecleaning. "The home," they wrote, "is considered a small industry, and every housewife its production engineer." Building on ideas put forward by American home economists as early as 1869, when Catharine Beecher wrote *The American Woman's Home*, they became the Henry Fords of dinnerware and entertainment.[6]

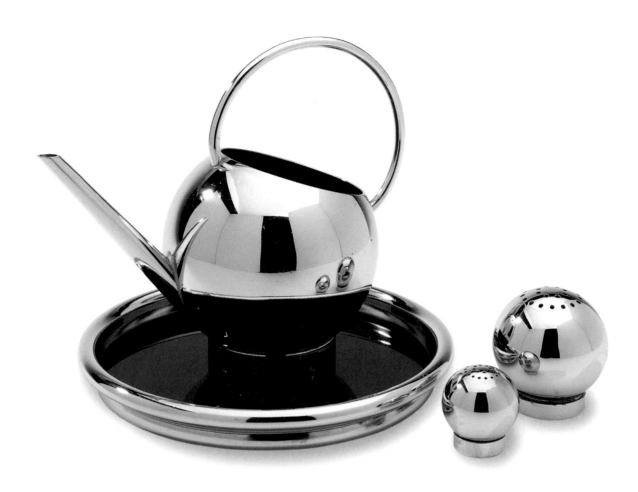

Corn set, chrome-plated brass, glass, ca. 1936

In addition to aluminum, Wright also experimented with other materials in the 1930s, as with this very modern set.

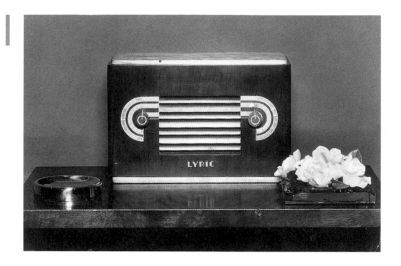

Depression Modern

Russel and Mary Wright entered the home furnishings arena in the early 1930s, when the start of the Depression and the end of Prohibition made an impact on the domestic environment. Small snack foods and economic one-dish casseroles became popular.[7] Hors d'oeuvres and finger foods were served at the newly revived cocktail hour.

Many of these trends were evident in Russel Wright's first line, Informal Serving Accessories, which included more than one hundred items, from initial serving pieces to later household items like lamps and decorative accessories.[8] Although he was also experimenting with such expensive materials and processes as pewter and chrome, it was the less expensive, newly domesticated material of aluminum that meshed with Wright's desire to reach a broad audience. In the same period, American designers Donald Deskey and Warren McArthur were also using aluminum for products ranging from wallpaper to furniture. Wright selected aluminum for its functional qualities: its lightness; its imperviousness to tarnish, peeling, or chipping; its resemblance, when treated with emery cloth, to pewter, which he considered a traditional material; and its ease of fabrication, a critical consideration since workers in Wright's workshop were producing these pieces. The serving accessories were later promoted for their practicality: the line "maintains heat or cold for long periods," a helpful feature for parties.[9] Inspired by Wright, Alcoa initiated the Kensington Ware line of aluminum accessories with Lurelle Guild as designer.

The streamlined Informal Serving Accessories line, begun around 1930 and developed for about five years, featured elegant, platonic shapes that possessed a strong volumetric presence. Cool aluminum was juxtaposed with wood knobs and handles; cork and rattan sleeves made the pieces warm to the touch. Only the exposed nails and

screws that connected aluminum to wood belie the objects' handmade origins. Easily fabricated by a spinning process, spheres constituted the essence of the line's punch set, ice bucket, and bun warmer (see pages 68–69). Spherical forms repeated in the cocktail set, with the added element of a vertical cylinder wrapped in cork that functioned as both the spout and the handle—a concept that would be further developed in the pitcher of the Iroquois Casual China line. On many pieces natural materials such as rattan are reserved for human touch, as in metal tubular furniture designed by Ludwig Mies van der Rohe and Marcel Breuer in the late 1920s and the leather-wrapped columns and stair rails in Alvar Aalto's late 1930s Villa Mairea in Noormarkku, Finland. The relish rosette, with different-sized concentric rings for displaying and serving party foods like olives, pickles, and deviled eggs, is a powerfully symmetrical target form that projects a sense of radial energy—like Wright's career itself, which radiated from the table to the landscape. Penny Sparke has commented that Wright "played a key role in transforming the aluminum object into an icon of modernity, an accepted domestic object that was closely integrated with feminine culture but, at the same time, manifested an uncompromising modern aesthetic."[10]

Mary Wright came up with the idea of marketing the line with themed informal parties that would require the serving accessories. These included Sunday Night Supper, Midnight Snack, After Bridge, Porch Picnic, and Tennis Refreshments. Retailers who sold the pieces were encouraged to use these themes in their store displays, complete with "dummy foods" to help the customer "visualize the items in use."[11] The Wrights used this marketing concept throughout their careers. Stranger iterations include the masculine Birthday Steak, illustrated in marketing materials as a large cut of meat decorated with candles for a "birthday party in tune with the times," and the

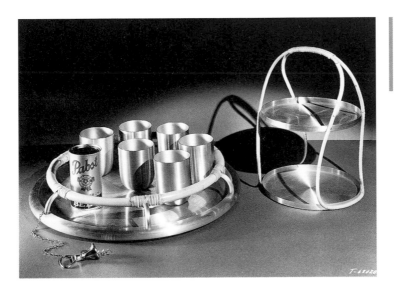

Promotional photograph for Informal Serving Accessories, early 1930s

Picnic in the Living Room, in which a woman converted the cocktail table into a dining table and the fireplace into a barbecue (see page 160). "Where is the man who won't bend his knees!"[12]

Based on the success of Informal Serving Accessories, Wright's name became increasingly known to manufacturers and retailers. The economic problems of the early years of the Depression forced manufacturers to use design to stimulate sales, and American designers such as Wright, Norman Bel Geddes, Donald Deskey, and Henry Dreyfuss were called upon to create new products. Wright soon branched out from serving accessories for the table. In addition to spun aluminum lamps, he was designing industrial products for the home, including a modern piano and radios for Wurlitzer. The radios, introduced at Macy's in 1933, were a radical departure from the "tombstone" models and the large consoles of the day.

As important as the Informal Serving Accessories line was in launching Wright's career, it was the Cowboy Modern chair he designed in 1932 that is the key to his later, best-known curvilinear designs. Originally created for himself, the chair features

Informal Serving
Accessories relish
rosette, early 1930s,
and Oceana rosette,
1935

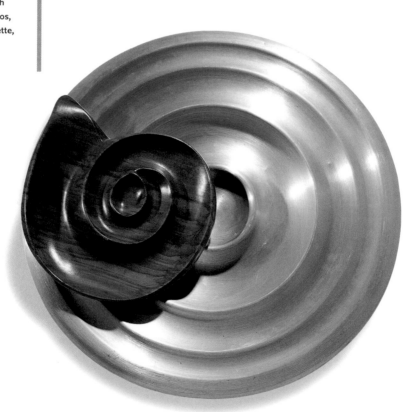

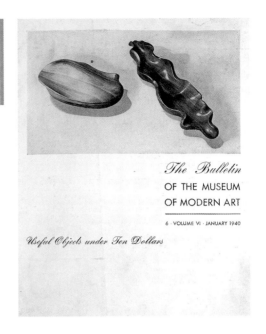

Oceana serving pieces,
The Bulletin of the
Museum of Modern Art:
Useful Objects under Ten
Dollars, January 1940

The Bulletin
OF THE MUSEUM
OF MODERN ART
―――――――――
6 · VOLUME VI · JANUARY 1940

Useful Objects under Ten Dollars

organically shaped wood arms, a ponyskin upholstered seat, and a thin pivoting back
of stretched vinyl (see page 94). Like subsequent furniture and dinnerware designs,
it has a low center of gravity that conveys a sense of comfortable stability. The chair,
which the Museum of Modern Art selected for its boardroom, remained a touchstone
in the career of Wright, who used it in both real and conceptual interiors as an
individualistic foil against simple forms.

In 1935 Wright designed Oceana, a line of wood serving pieces manufactured by
Klise Wood Working Company of Grand Rapids, Michigan. Oceana's organic forms,
executed in hardwoods, including maple and cherry, echoed the arms of the Cowboy
Modern chair and supplied an unexpected, surreal twist to the table. The biomorphic
cadenzas of the line were inspired by marine life, such as shells and plant forms.
The elongated centerpiece bowl resembled rippling water, while a nautilus shell
was transformed into the snail relish dish. Each piece maintains a strong sculptural
quality, despite its machine production. Beautiful and inexpensive, Oceana was
featured on the cover of a 1940 Museum of Modern Art bulletin announcing *Useful
Objects under Ten Dollars*, part of a program that sought to bring modern design to
the masses.

Wright's inimitable forms are analogous to the organic lines of sculptor and
painter Jean Arp, who shifted from organic reliefs to sculpture in 1930–31. As critic
Herbert Read has described, Arp rendered subtle transformations of natural forms.[13]
During the 1930s, biomorphic forms emerged in design and the decorative arts as
well. Wright, too, drew inspiration from the natural world in the Oceana line as well

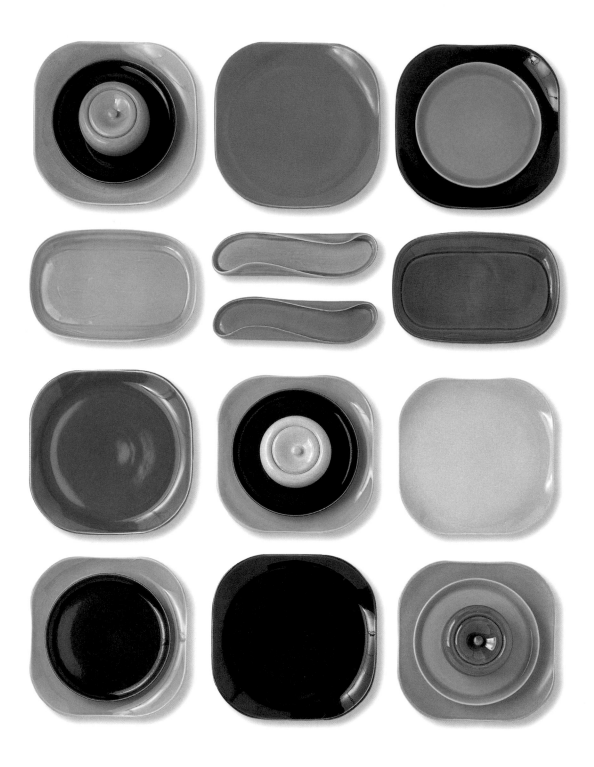

American Modern dinnerware, earthenware, 1939

as in other designs that followed. As was often the case, design was responding to aesthetic ideas first explored in art.

Far more important to Wright's future as a designer of integrated lines of home products was his sixty-piece furniture line for the Heywood-Wakefield Company (see page 88). Introduced at Bloomingdale's in 1934, it featured curved edges, simple pulls, and veined veneers that echoed home furniture designed by Donald Deskey in the late 1920s and early 1930s.[14] (Heywood-Wakefield had insisted upon using veneers to connect the furniture to fashionable European Art Deco.) The ensembles projected an urban sophistication, as stepped endtables were combined with oversized upholstered chairs and low storage units attached to sectional sofas—thought to be a Wright invention. Applying the veneer proved problematic, however, and caused long delays in shipping. The real innovation was less in the furniture's style and construction than in its marketing. Although the line did not sell well, it was conceived as individual pieces rather than as conventional suites. Customers could buy any combination of pieces to suit their personal needs. This new concept of flexible "open stock" became an essential element of Wright's future designs for the home.

American Modern

The failure of the Heywood-Wakefield line did not deter Wright. Rather, he immediately launched into the design of a line of solid wood furniture, produced by Conant Ball of Massachusetts in 1935. This furniture was distinctive for its pared-down "20th century interpretation of the spirit behind American Colonial design—a spirit which prompted frank construction and honest simplicity."[15] It was made of northern solid rock maple and was available in two finishes—one dark, to complement traditional interiors, and one light, coined "blonde" by Mary Wright, for more modern tastes (see pages 92–93). With more than fifty pieces that could be used in living rooms, dining rooms, bedrooms, and throughout the house, the line offered stylistic variations: one desk, for example, was asymmetrical with a cantilevered top; the other was a more traditional kneehole form that sat solidly on the ground. All the pieces featured rounded corners, or "cushion edges" as Wright called them, which set them apart from most modern furniture and were practical because they reduced chipping. Sales materials stressed that "heretofore furniture of modern design has been directed mainly toward the Metropolitan pocket-book and Metropolitan tastes. American Modern has a far wider appeal.... The majority of modern furniture...on the market today...is so extreme that it looks out of place in an average suburban home or apartment."[16] Conant Ball marketed the furniture at its "lowest prices," and Macy's sold the cantilevered desk for $19.99 (approximately $250 in 2001).[17]

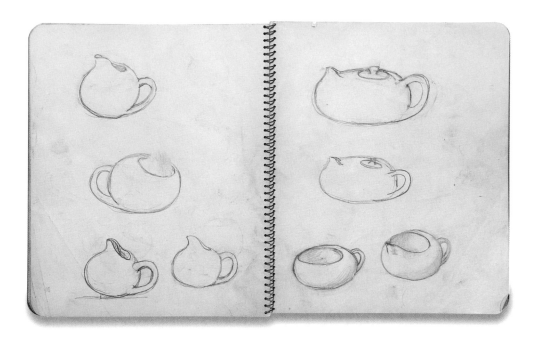

American Modern was not as progressive as contemporary furniture by European modernists like Alvar Aalto, who was using industrial molded plywood. However, like the work of other Americans such as Deskey and Gilbert Rohde, the American Modern line radically simplified form and eliminated ornament, representing a major turning point in America's design aesthetic. American Modern, according to O. L. Overby, a furniture buyer at Macy's, was "the most important development in American furniture in the last few decades." Noting the many imitations that followed, Overby claimed that the idea of American Modern "has now become a species!"[18]

The natural development of the American Modern brand was Wright's next dinnerware line, which revolutionized the American table in form and content. Manufactured by Steubenville Pottery in Ohio, American Modern featured such innovative undecorated shapes and unusual colors that the Wrights were forced to search for years to find a manufacturer who would make the line. (And still, the Wrights themselves had to finance making the molds.) Introduced in late 1939, American Modern was conceived as casual tableware that fulfilled several functions: the serving pieces could also be used on the stove or in the oven, thereby eliminating additional cookware; the chop plate doubled as a tray for the tea set; and the carafe could be used to serve water, wine, coffee, or tea. This functional aspect would be developed by Wright in later additions to the line, which included divided bowls that held two different vegetables, double-decker stacked sets that saved space on the table, and a hostess plate that held a cup inside an indented oval and allowed people to easily navigate an informal party (see page 73). These clever devices reduced the number of dishes needed for a basic set and

Sketches for American Modern dinnerware, graphite on paper, mid-1930s

were well suited to the small houses and apartments into which young couples were moving. Initially, in 1939, "starter sets" of at least three sizes—for four, six, or eight people—were offered, as was open stock. The New York store Modernage offered a thirty-three-piece starter set, which served six, for $14.50. As Ann Kerr noted, "One's service was never quite complete, but never incomplete either."[19] The concept went a long way toward breaking up the old "china set" and letting consumers reconceive their own set of dishes.

The shapes of American Modern ranged from the simple to the eccentric. Round, rimless, stackable dinner plates—or "coupes," which were tailored to buffet dining—were a Wright innovation. (The main function of the rim he eliminated was for decoration, which Wright considered unnecessary in the modern American home. Instead, the decorative effect of the new dinnerware derived from its shape, color, and glaze.) An undulating celery dish, an elongated pitcher, and a gravy boat with a cantilevered handle all seemed propelled into motion. The sides of the salad bowl were folded inward to confine leafy greens. The coffeepot and teapot were as witty and effervescent as a screwball comedy by Wright's contemporary, Preston Sturges.

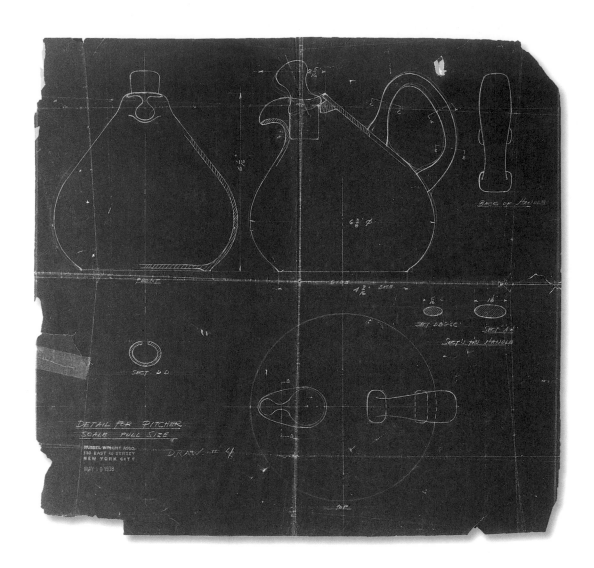

Drawing of American Modern pitcher, diazo print, 1938

Wright's American Modern line applied the organic wood forms of the Oceana serving pieces to dinnerware. A handwritten note on a page from Wright's sketchbook referred to "abstractionists like Arp," specifically connecting American Modern to the work of the famous Surrealist artist. Similarly, Wright's evolutionary studies of vessels, handles, and spouts are akin to Arp's aesthetic process. "Art is a fruit that grows in man," Arp wrote, "like a fruit on a plant, like a child in its mother's womb."[20] This approach can also be applied to Wright's task, but because it included function it was thus more complex than the sculptor's.

The colors of American Modern also represented a departure from convention. Nonwhite solid-colored dinnerware had been introduced to the general market in the early 1930s by Catalina Clay Products, but its most famous form was Fiestaware, designed by Frederick Rhead in 1935.[21] In contrast to Fiestaware's circuslike bright colors and geometric forms, American Modern's earthy palette and variegated glazes were as organic as its shapes. Coral, Seafoam Blue, Chartreuse Curry, Granite Gray, White, and Bean Brown were the first colors offered. The informal flexibility of the line allowed customers to mix and match place settings of different colors. By adding decorative accessories to table settings, homemakers could "change the scene," as Russel Wright claimed in 1954. Wright illustrated in a magazine article how American Modern dinnerware, "like a little black dress," could be accessorized with an international array of decorative elements to create Scandinavian, Mexican, American, and Asian dinners.[22]

The success of American Modern can be judged from the fact that it won the American Designers' Institute Award in 1941 for Best Ceramic Design of the Year; it became one of the best-selling tableware lines in history and reputedly grossed $150 million in sales; and Steubenville Pottery expanded twice to keep up with demand for the line. Production ended only with the closing of the company in 1959.

Not everyone agreed with its popular appeal. In 1944, Manny Faber, a critic at The New Republic, blasted American Modern. Because it "threatened to become so much of an American institution," he felt compelled to write about it. "You can spot Wright's 'American Modern Dinnerware' without much trouble," he wrote, "by its qualities of steeliness, nudity, hammerlike statement and chi-chi color."[23] Wright agreed with some of the criticisms but vehemently disagreed with what he perceived as Faber's elitist disdain for mass-produced goods. Wright believed that industrial designers could spread the innovations of fine artists to the general public by being "preachers." As the next phase of Wright's career would prove, he was just such a preacher, creating not only the objects of an improved everyday life but the secular bible with which to achieve it.

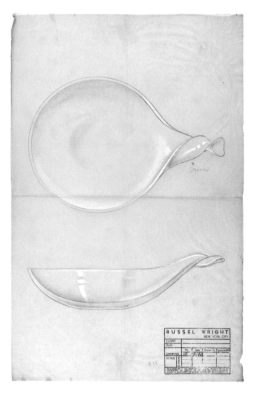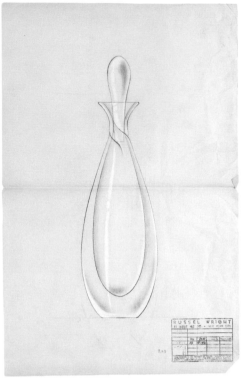

Postwar Pottery

After World War II, American families were able to make substan-
tial purchases following almost fifteen years of deprivation and
rationing. Soldiers of the new peace and consumption, they
outfitted new homes in suburbia where they "needed all [the]
new labor-saving, life-enhancing products that came on the
market in the postwar era," including air-conditioning, frozen
foods, and fitted sheets.[24] Advertising stimulated the public's
interest in new products made available by industry's need to
convert from military to civilian production.

 Although American Modern continued to sell very well,
Wright developed a new design direction by working with the
Bauer Pottery Company of Atlanta, Georgia, to produce a line of
approximately twenty vases, candlesticks, and other decorative
objects. Produced only from 1945 to 1946, Bauer, as the "art
pottery" line is known, was an aesthetic tour de force but a
commercial failure. Rough, emphatic forms combine with thick

Sketch of Rustic dinnerware (not produced), graphite and pastel on paper, ca. 1942

Country Gardens
butter plateau and
cruet in dark green,
whiteware, designed
by Mary Wright,
1946

silica glazes to offer the postwar homeowner rugged antidotes to the mass-produced houses that were starting to spring up, from Levittown to suburban Los Angeles. And perhaps in contrast to growing pressures of conformity, Wright designed the Bauer pieces to attain an individualized expression. The heavy pottery and lavalike glazes reacted unpredictably when fired, creating subtly different shapes and textures. Smooth black interiors contrast dramatically with exterior glazes that range from Jonquil Yellow to Bubble White and Atlanta Brick.

Mary Wright had designed some wood and aluminum pieces in the 1930s, but in 1946 she created her only complete dinnerware line, Country Gardens, for the Bauer Pottery

Company. Developed with Doris Coutant, Russel's own glaze and ceramics consultant, the glazes included mottled green, pink, beige, brown, and white. The overall effect evoked traditional Asian design, but a characteristically American ingenuity can be seen in the covered sugar bowl, whose lid doubled as a spoon (see page 78). When the line was unveiled, buyers were not impressed, and the line never went into full production.

Disillusioned by their attempts to push the boundaries of the pottery market, the Wrights returned to their popular roots in 1946, when they created Casual China for the Iroquois China Company. This gave them the opportunity to correct some of the flaws that had become apparent in American Modern and to seize the newly affluent middle-class market with dinnerware that had all the assets of real porcelain without its fragility. It had become clear that American Modern pieces were prone to chipping, breaking, and crazing. With manufacturers actively promoting automatic dishwashers for the postwar home, such breakage was even more likely than before. To correct the problem, Wright used a special clay formula for Casual China and had the dinnerware fired at 2,300 degrees Fahrenheit, an unusually high kiln temperature, which increased its durability. Iroquois China Company guaranteed the china against chipping or breaking for three years, although previously they had guaranteed their wares for only one. Casual China, the only American-made china of the time available in solid colors, was introduced by the Iroquois company with two other, more decorative, patterns designed by Ben Seibel.[25] Iroquois's guarantee highlighted the idea of permanence to war-weary Americans—in fact, the plates probably outlasted many a marriage.

Sterling ashtray in Suede Grey, earthenware, ca. 1949

The Sterling China Company, a supplier of restaurant china, marketed this Russel Wright line to both institutional and domestic customers.

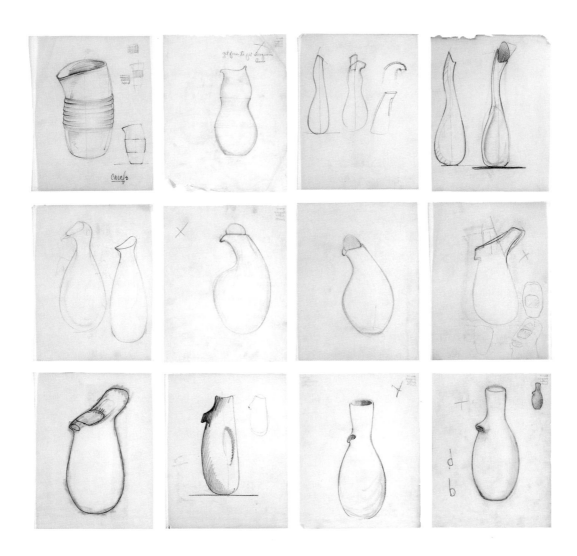

Iroquois Casual China carafe studies, graphite on trace, ca. 1946

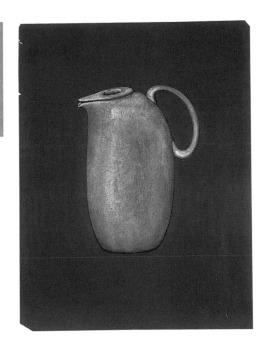

Presentation drawing
for Iroquois Casual
China redesigned
pitcher (not
produced), graphite
and pastel on paper,
1952

Iroquois Casual China was a solid line but not nearly as experimentally expressive as American Modern. It elaborated upon many of the functional innovations of the earlier line and added a new array of colors, including Sugar White, Ice Blue, and Lemon Yellow, and later Charcoal, Ripe Apricot, Pink Sherbet, and Cantaloupe. In 1949, the line was expanded with additional colors, new pieces, and smoother glazes that abandoned the earlier mottled, raindrop glaze, the last vestige of the Bauer line's eccentric irregularity.[26] The line was discontinued in 1966, after various attempts by Russel to redesign it. Ironically, Iroquois abandoned Casual China in favor of a line of Early American dinnerware reproduced from the collection of the Henry Ford Museum outside Detroit. The man who fought so hard to create a twentieth-century interpretation of historical American design was undone by an uninspired copy.[27]

In 1946, while Wright was launching Iroquois Casual China, the newly formed Castleton China Company introduced Museum, a line of porcelain china designed by Eva Zeisel at the recommendation of the Museum of Modern Art. Zeisel was suggested by Eliot Noyes, director of the museum's industrial design department. He had seen her work at Pratt Institute in Brooklyn, where she was teaching, and later attended a lecture she gave at the Metropolitan Museum of Art in 1942 on the relationship between mass-production and craft.[28] In addition to Wright, Zeisel was the only other designer who "greatly expanded the frontiers of American tableware," according to curator Charles Venable, and the dinnerware lines they created in the 1930s and 1940s engage in an aesthetic and functional dialogue.[29] Born in Hungary in 1906,

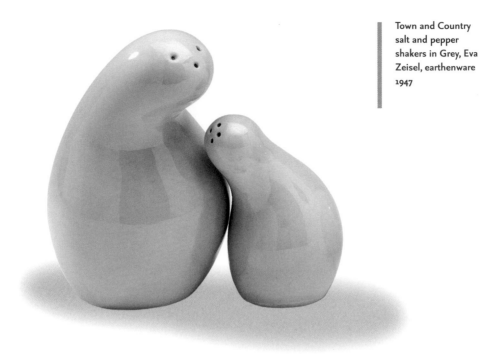

Zeisel trained in her native country and Germany, where she became immersed in the modern movement. Her Museum line featured undecorated, off-white china in graceful, purist profiles with "curves extending into straight lines."[30] Like Wright's work, Museum redefined formal dining for new American lifestyles, and its beauty derived from its elegant color and shapes. Though critically acclaimed and ultimately highly influential with other designers, it was not commercially successful.[31] Wright appeared to pay a compliment to Zeisel's Museum design in his Theme Formal line of the early 1960s, but even before then Zeisel had responded to American Modern with Town and Country. Released in 1947, the earthenware service for Red Wing Pottery of Minnesota represented a strong shift in Zeisel's aesthetic from Museum's propriety to the fun-loving, American forms pioneered by Wright's American Modern. Town and Country's intertwining salt and pepper shakers and tear-shaped cruets have an anthropomorphic, cartoonlike humor. The lively, mix-and-match palette also pays homage to American Modern.

Easy Living

How could all these lines of dinnerware and furnishings be combined to make life easier for the average American family? What in fact were the essential characteristics of American lifestyle? And how could the public be urged to adopt it? Mary and

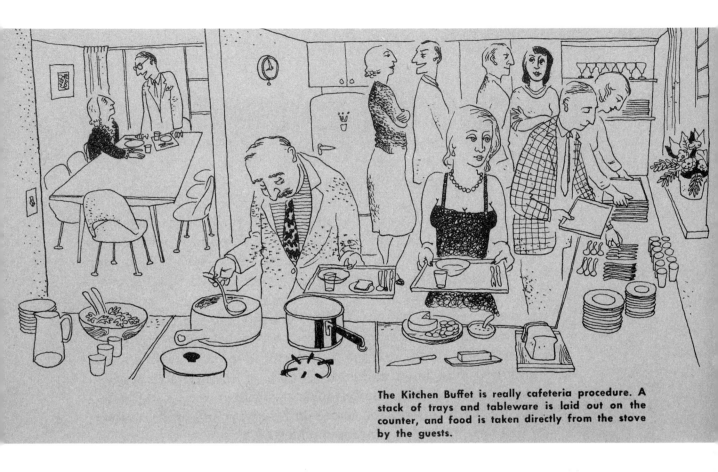

The Kitchen Buffet is really cafeteria procedure. A stack of trays and tableware is laid out on the counter, and food is taken directly from the stove by the guests.

Russel Wright's *Guide to Easier Living*, which Simon and Schuster published in 1950, provided their answers. The book covers both how to plan and design a home that facilitates modern living and how to achieve efficient housekeeping and casual entertaining. They advised their readers on sensible housecleaning standards and efficient routines to meet them. "The basic idea is itself simple," the Wrights wrote. "Eliminate unnecessary steps and motions in your work, combine, rearrange, make them easier. The desired result is housekeeping minus all that is unnecessary, unduly arduous, and time-consuming."[32]

The Wrights devote much of the book to entertaining in accord with the new social rules that governed suburban, middle-class living. In the late 1940s, many Americans moved out of the cities to new suburbs and planned communities, where they were surrounded by anonymous neighbors instead of family. As a result, they sought a new etiquette, which the

Kitchen Buffet illustration from *Guide to Easier Living*, 1950

Wrights provided in a variety of ways. Railing against the Emily Post style of formal entertaining in which the hostess "begs her guests not to lift a finger," the Wrights proposed "a new set of manners for both hosts and guests" that were "truly gracious, because they are sincere…. The traditional forms of entertaining have hundreds of rules and dictates, whereas the new etiquette has only one basic principle: to make entertaining less work and more play for everyone concerned."[33]

The prototype for the Wrights' concept of informal entertaining was the picnic because "everyone helps to make and serve the meal and make the entertainment."[34] The Wrights brought the picnic indoors with meals that served as blueprints to restructure the relationships between husband and wife, parents and children, and hosts and guests. Meals divided into two general types: All-at-the-Table for seated meals and Bring-it-to-the-Table for buffets.

The Co-operative Meal was an all-at-the-table collaborative feast of activity and activation, of choreography and placement (see pages 74–75). The corners of the table were set with the main course, bread, coffee service, and a water pitcher plus glasses. Secondary food items, such as salad, dessert, and butter, were positioned down the center of the table. Each person

Picnic illustration from *Guide to Easier Living*, 1950

Seated Buffet illustration from *Guide to Easier Living*, 1950

Snack Meals illustration from *Guide to Easier Living*, 1950

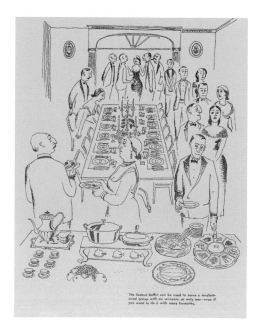

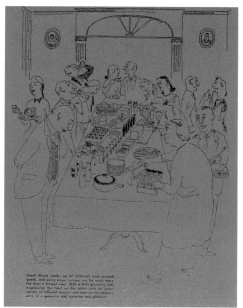

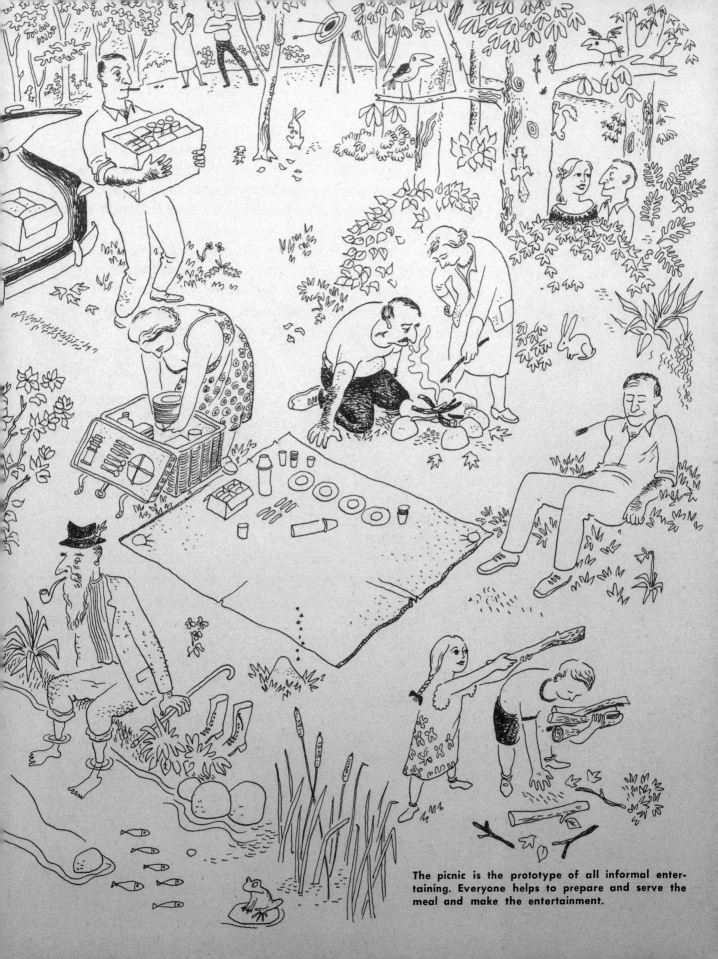

The picnic is the prototype of all informal entertaining. Everyone helps to prepare and serve the meal and make the entertainment.

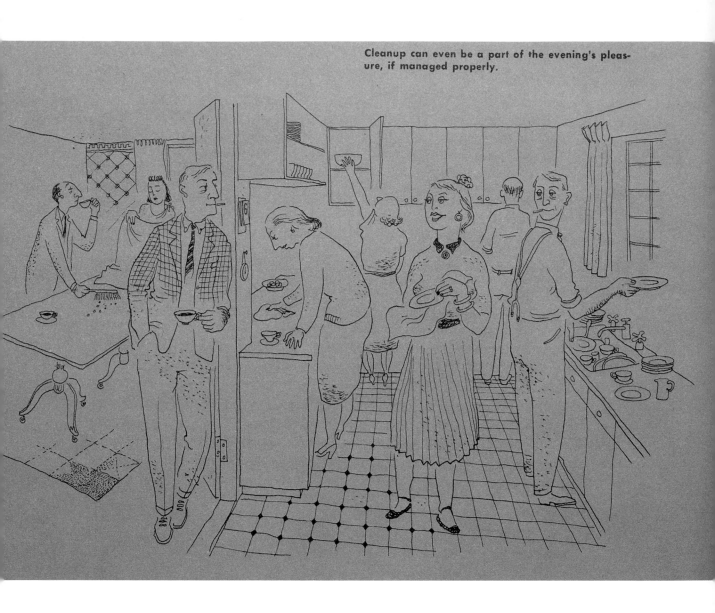

Cleanup can even be a part of the evening's pleasure, if managed properly.

Cleanup with Guests illustration from Guide to Easier Living, 1950

Conventional Setting	Family Cafeteria Setting
1 tablecloth	—
4 fabric napkins	4 paper napkins
4 dinner plates	4 dinner plates
4 soup plates	—
4 salad plates	1 wooden salad bowl
4 bread-and-butter-plates	1 butter dish
4 dessert plates	4 dessert bowls
4 water glasses	4 water glasses
4 cups	4 coffee mugs
4 saucers	—
4 knives	1 cutlery tray (holding 4 knives,
4 forks	4 forks, 4 spoons)
4 salad forks	1 scissor salad server
4 soupspoons	—
4 dessertspoons	—
4 butter spreaders	1 butter knife
4 teaspoons	—
1 meat platter	—
2 vegetable serving dishes	1 casserole
1 gravy boat	—
1 dessert serving bowl	1 dessert serving bowl
2-piece carving set	—
1 gravy ladle	—
3 serving spoons	3 serving pieces
1 salt	1 salt-and-pepper set
1 pepper	—
1 sugar bowl	1 sugar bowl
1 cream pitcher	1 cream pitcher
1 bread basket	1 bread basket
1 water pitcher	1 water pitcher
	1 coffee maker (and server)
Total: 82	Total: 36

Chart from *Guide to Easier Living*, 1950, comparing the number of pieces needed for a traditional table setting to that needed in the Wrights' scheme

Highlight salad plate and saucer in Snowglass, glass, and cups in Nutmeg and pepper, whiteware, ca. 1951

Highlight creamer in
Nutmeg nested with
cup in Citron, white-
ware, ca. 1951

served the course placed to his or her right. "Careful arrangement makes the table attractive," the Wrights wrote, "and division of labor keeps the service smooth."[35]

The Family Cafeteria dinner setting arranged the meal in a T-shape with cutlery, plates, rolls, butter, water pitcher, and glasses along the cross of the T at the edge of the table (see pages 80–81). The main course, salad, dessert, and serving utensils formed the bar of the T, down the center of the table. Diners gathered the items for their place setting before taking their seats. In the Wrights' version, the informality of the Family Cafeteria setting reduced the dinnerware needed for a conventional dinner for four people from eighty-two to thirty-six pieces. The Wrights rationalized the dinner table into an assembly line.

The Kitchen Buffet was the Wrights' most informal proposal. They recommended setting plates, utensils, and even cafeteria-style trays on the kitchen counter, and having guests serve themselves directly from the stove. Throughout the Guide, the Wrights emphasized having table setups completely readied before guests arrived to enhance the impression of effortless serving, when actually much complex planning occurred in advance. After the meal, guests were encouraged to help clean up. If managed properly, the Wrights proclaimed, "Cleanup can even be a part of the evening's pleasure."[36]

The Wrights cleverly featured abstracted drawings of dinnerware throughout the book to demonstrate table settings, leaving room in the reader's imagination as to the kinds of dishes that could be used. American Modern and Iroquois were perfect candidates, as they had been designed for exactly this kind of informality. Just after

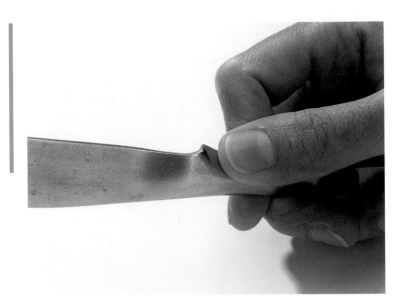

Detail of Highlight/Pinch knife handle, stainless steel, 1953

The upper part of the Highlight/Pinch knife handle cradles the thumb and provides leverage.

publication of the book, the Wrights added another line, Highlight, that was equally well suited. The distinctive line contrasted pieces of opaque pottery (in a palette of Nutmeg, Blueberry, Pepper, or Citron) against others of translucent Snowglass, which lent sophistication to casual entertaining.

When Wright applied the easier living principles to his own life, he engineered every last detail. For use at his home on 48th Street in New York as well as at Dragon Rock, his home outside the city, he developed a menu book that included one hundred recipes paired with table settings from which he permitted no deviation. He obsessively established a numerical list of meals for the week, which eliminated any confusion for a succession of housekeepers (whose presence became necessary after Mary Wright's death in 1952). Wright's menu book also ensured "an expressive setting" for each meal, ranging from lunches served cafeteria style in the kitchen to buffet dinners. His most spectacular dinner featured Chinese Chrysanthemum Duck served in a bronze chafing dish with a blue flame beneath it. The meal started after a white chrysanthemum was scattered into the stew.[37]

The lifestyle concepts of the Wrights required more than dinnerware, and in the years around 1950, Wright designed a constellation of easier living goods, from outdoor furniture for Samsonite "with the weather proof automobile finish!" and Highlight/Pinch flatware, named for the ergonomic indentation in its handle, to colorful patterned table linens in cotton that were easy to maintain. The Wrights filled *Guide to Easier Living* with examples of traditional furniture that could be easily integrated with modern pieces by such leading designers as Charles and Ray Eames, Eero Saarinen, and Wright himself. The Wright samples were from a line called Easier Living,

Drawing of Highlight/Pinch flatware, gouache, ink, chalk, and graphite on paper, 1950

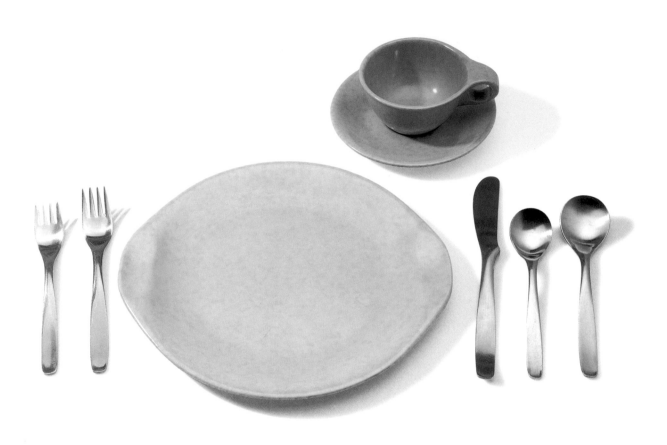

Residential dinnerware in Seafoam, 1953, and Highlight/Pinch flatware, 1953

Design models of cutlery, metal, wood, clay, no date

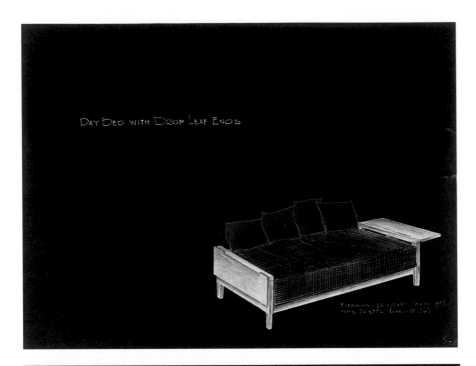

DAY BED WITH DROP LEAF ENDS

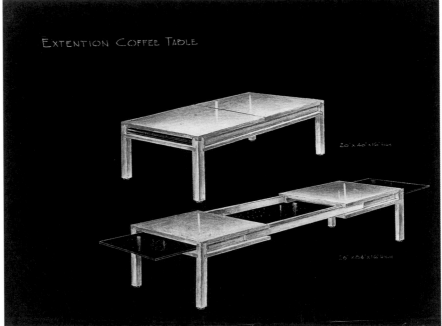

EXTENTION COFFEE TABLE

Renderings of Easier Living furniture, reverse diazo and colored pencil, ca. 1950

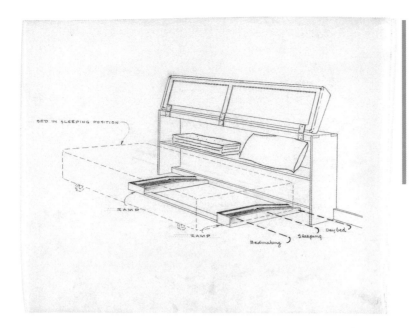

BED IN SLEEPING POSITION

RAMP

RAMP Day bed

Bedmaking Sleeping

Drawing for Easier Living bed, graphite on trace, ca. 1950

The clever features of this headboard and sliding bed frame typify the Easier living furniture line. Only the headboard was produced.

introduced in 1950 by the Statton Furniture Company of Hagerstown, Maryland. The line's flexible, multipurpose innovations updated historic furniture elements. The Reading and Writing chair, for example, featured two drop leaves—one on the right that formed an endtable and one on the left that became a magazine rack (see page 163). Coffee and dining tables had built-in leaf extensions for expandability. Even though it was conceived and marketed according to "the needs of people—particularly the overworked housewife," Statton's Easier Living line did not sell well.[38]

Nothing conveyed the increased "easier living" casualness of postwar dining habits better than the introduction of plastic dinnerware, a revolution at the American table in which Russel Wright was a major force. Before World War II, plastics—particularly Bakelite—had been used for radios, jewelry, and other objects. Plastic dinnerware existed in the form of picnic sets and airline dishes.[39] Wartime developments improved plastics technically, and the productive capacity of chemical companies like Dupont and American Cyanamid increased. (The Navy, understandably, used unbreakable plastic dishes.) After the war, raw material manufacturers sought new civilian markets and worked with designers and entrepreneurs to launch new plastic dish sets. By 1950 at least twenty makers of plastic dinnerware existed in the United States, and many households were using plastic as second and third sets of dishes.[40]

The design of postwar plastics advanced along two fronts. Designers and architects like Eero Saarinen, Charles and Ray Eames, Eva Zeisel, and George Nelson created furnishings in new, unusual shapes expressive of a new material. Representing the avant-garde, their experiments ultimately led to iconic Pop designs of the 1960s by

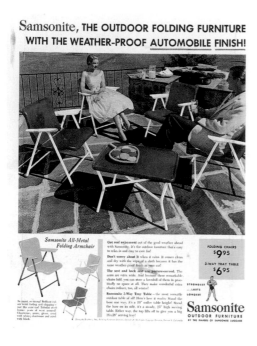

Verner Panton and Joe Columbo. In contrast, Russel Wright focused more on lifestyle issues, specifically how to achieve elegance with inexpensive, unbreakable plastic—an important concern to mothers of young children. In his efforts, he was not unlike Earl Tupper, who launched Tupperware in the late 1940s. Instead of forging a new aesthetic, Wright plasticized conventional dinnerware by imitating the look, feel, and weight of traditional ceramics.

Wright, working with American Cyanamid, became a central figure in the emergence of plastic in the home. After the war, American Cyanamid trademarked their version of melamine plastic as Melmac and hired Russel Wright to develop prototype dishes using the material. He created Meladur, which was embraced by restaurants after its introduction in 1949. At the same time, American Cyanamid launched a major national advertising campaign in trade journals and popular magazines, eventually setting up Melmac Centers in stores.

Wright continued to refine the molding and textures of Melmac to make it more suitable for domestic dinnerware, and in 1953 he brought out Residential. Receiving Good Design Awards from the Museum of Modern Art in 1953 and 1954, Residential was three years later "the best-selling door-to-door tableware in America, with gross sales of $4 million."[41] Wright, more than any other contemporary designer, was associated in the public's mind with plastic dinnerware. An October 1957 *Better Homes and Gardens* ad for Melmac dishes featured more than a dozen lines, each identified by name. Residential was the only one to carry a designer label—Russel Wright.

Residential dinner plate in Seafoam, 1953, and Samsonite folding outdoor chair,
ca. 1950

Presentation drawings of nasturtium flowers for Iroquois Casual China, ink on board, ca. 1955

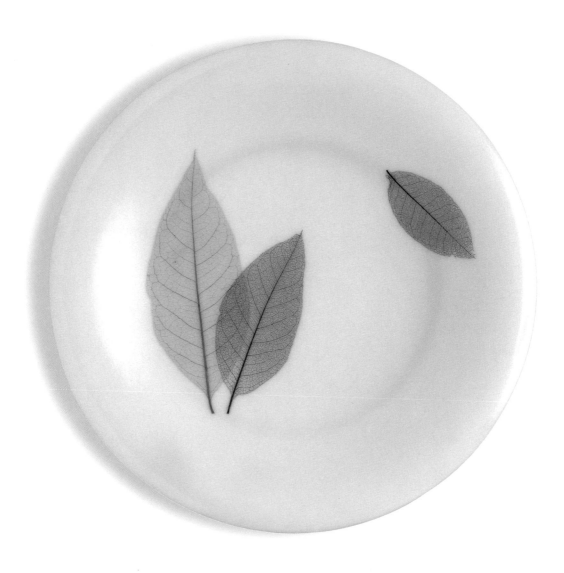

Flair dinnerware in Ming Lace Leaves, melamine plastic with leaves, 1959

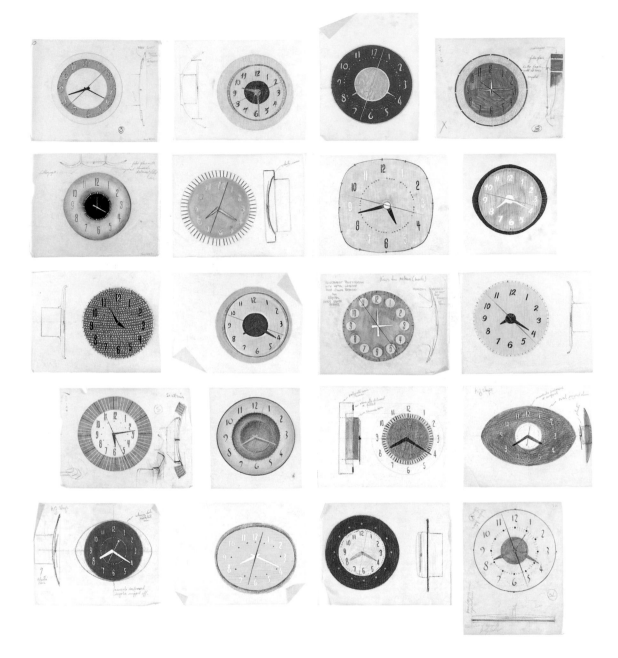

Drawings for Ceramic clocks, mixed media on paper, ca. 1952

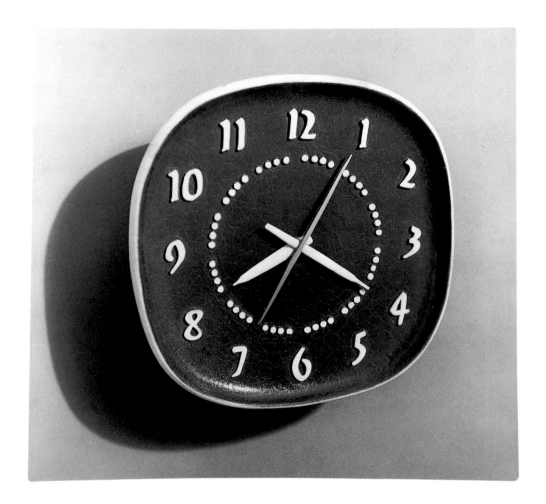

Ceramic clock in Charcoal, earthenware, 1952

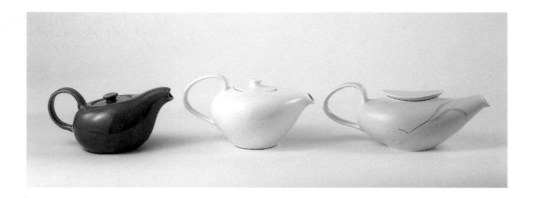

through this line of decorated and undecorated plates: Harker
revels in the stark contrast between the white plate bottoms or
bowl interiors and the colorful plate faces or bowl exteriors.
Every piece continues the play of line against surface, as in the
revealed white rims. The natural motifs move gracefully and
centripetally in the center of pieces or along now-delineated
edges. Within one setting, there is a splurge of American
variety. Children in the 1950s might scamper under their school
desks in fear of the bomb, but home life achieved a certain
Eisenhower opulence.

Wright's Ceramic wall clock, designed for any room of the
house, accompanied the Harker line and was distributed by
General Electric. Its undecorated, platelike face was molded
out of a single piece of semivitreous china with integral color
fired on. Wright deliberately selected the colors to match the
palette of White Clover and to coordinate with other General
Electric products, such as kitchen appliances. In its broad
advertising campaign, GE matched the thoroughness of Wright's
design process.[42]

The aristocratically titled Knowles Esquire line was produced
from 1955 to 1962—the era between Joe McCarthy and the
Cuban missile crisis, a paranoid epoch of American history and
the Cold War. Meanwhile, Russel Wright continued his private
drama of abstract pattern. In Knowles Esquire, naturalistic
pattern was inserted as an underglaze, and gold accents were
added as an overglaze. The form of the line derived from an
extended oval with gentle flares. Patterns ranged from Grass to
Queen Anne's Lace, Seeds, and Snowflower. The line did not

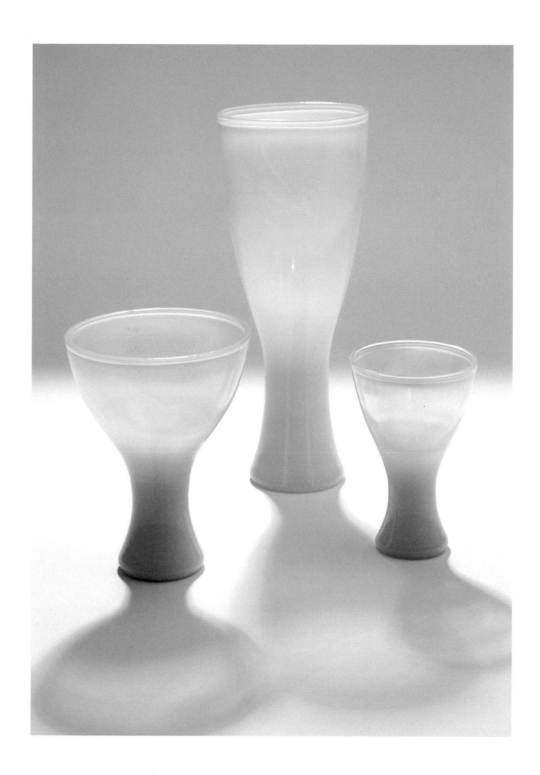

Theme Formal glassware, glass, 1965

Esquire platter in Grass, earthenware, 1956

following pages: **Cocktail Hour**

"We are making a new etiquette, with a new set of manners for both hosts and guests.
They are better manners, more truly gracious, because they are sincere, not a
counterfeit of a vanished aristocracy but an honest product of our times. What they
demand, more than anything else, is a new and more relaxed attitude on the part
of all concerned." —*Guide to Easier Living*

succeed, perhaps due to the poor way its subtle palette reproduced in black-and-white photography, which was key to newspaper advertising and catalog promotions.[43]

Wright was obsessed with combining new materials with natural imagery. For Flair, a dinnerware line of Melmac plastic launched in 1959, Wright developed four patterns: Spring Garden, Arabesque, Golden Bouquet, and Ming Lace Leaves. For the last, the most innovative of the line, he tinted real jade orchid leaves imported from China and embedded them in the dishes, adding variety and individualization to mass-produced wares. Wright adapted this collage idea to architectural scale in his own house at Dragon Rock, where he embedded butterflies (before Damien Hirst) in a bathroom wall and hemlock needles in the walls of the living room.

Wright's final dinnerware design was for two contrasting but complementary lines—Theme Formal and Theme Informal, introduced in 1965 and manufactured by Yamato in Japan. In the glassware of Theme Formal, the white opacity at its base shifted through translucent gradations in the body and ended with a whitened flourish along the rim. The sophisticated Theme Formal dinnerware was out of synch with the times, as casual lifestyles had been adopted by many Americans with a vengeance, due in no small part to Wright's own efforts.

Russel Wright clearly is an American original. With Mary, he invented the best-selling dinnerware lines of their era, the season of America's bourgeois apotheosis. In an age of consumerism, Wright created a fine level of distinctly elegant and even subtle ensembles. His ergonomic approach was prophetic, foretelling today's finely honed, user-friendly objects, such as Oxo Good Grips kitchen tools. He continually adjusted the sculptural volumes of his dinnerware until they reached a formal perfection of interknit parts. In color, shape, and functionality, these new solutions survive to give us more than a period pleasure. The pieces have an afterlife in which the uncontrollable aesthetic has taken over and proffers a magnanimous gift. Wright created a table truly well set.

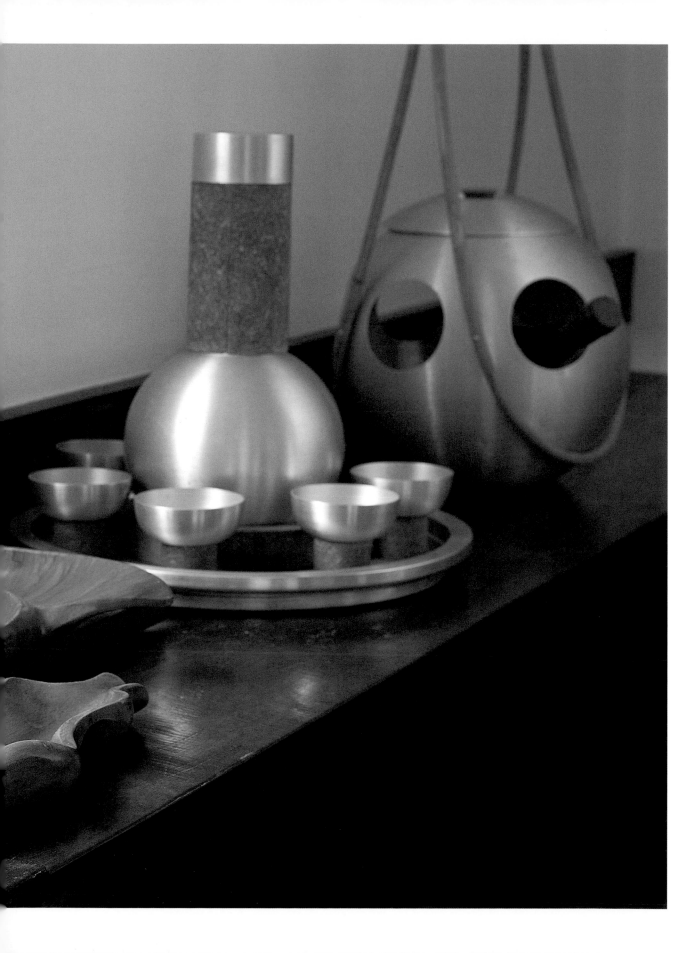

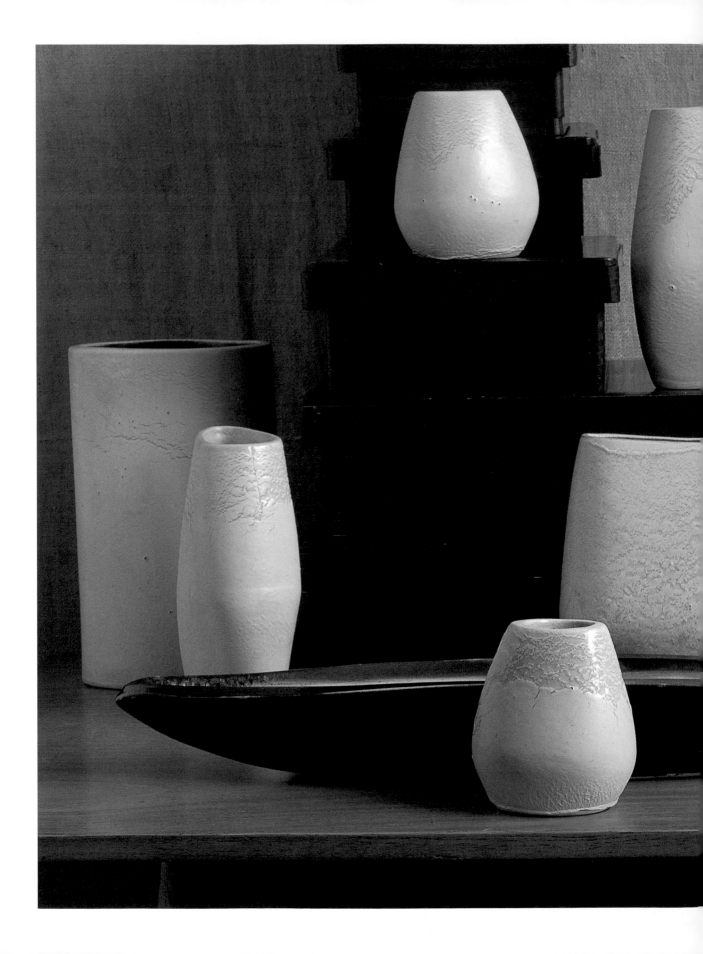

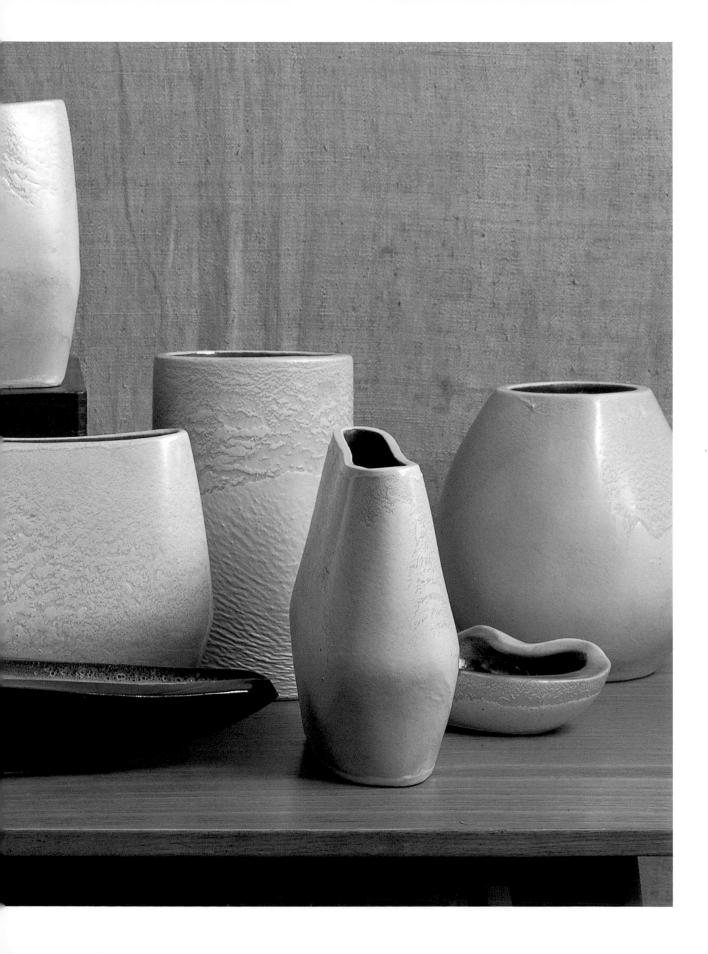

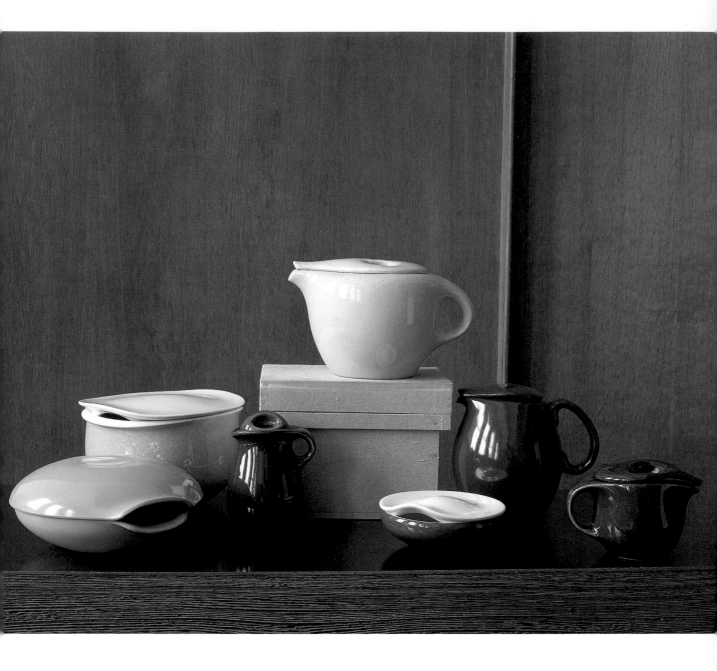

Formal Variations

previous pages: **Lavalike Glazes**

"Of course you love your friends. But do you still love them when the party's over? When you've slaved to prepare for them, and still have to clean up after them when they're gone?" — Guide to Easier Living

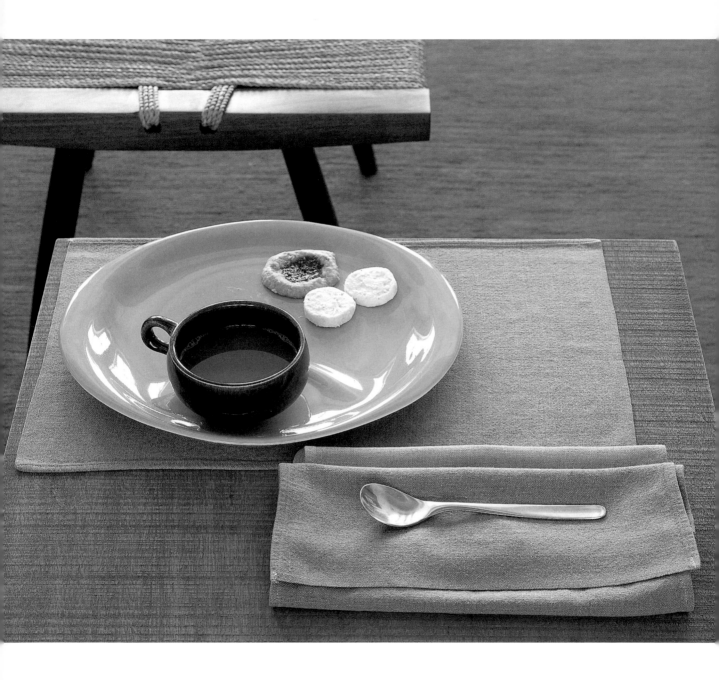

Modern Hostess

following pages: **Cooperative Meal table from** *Guide to Easier Living* **(see pages 44–49 for a description)**

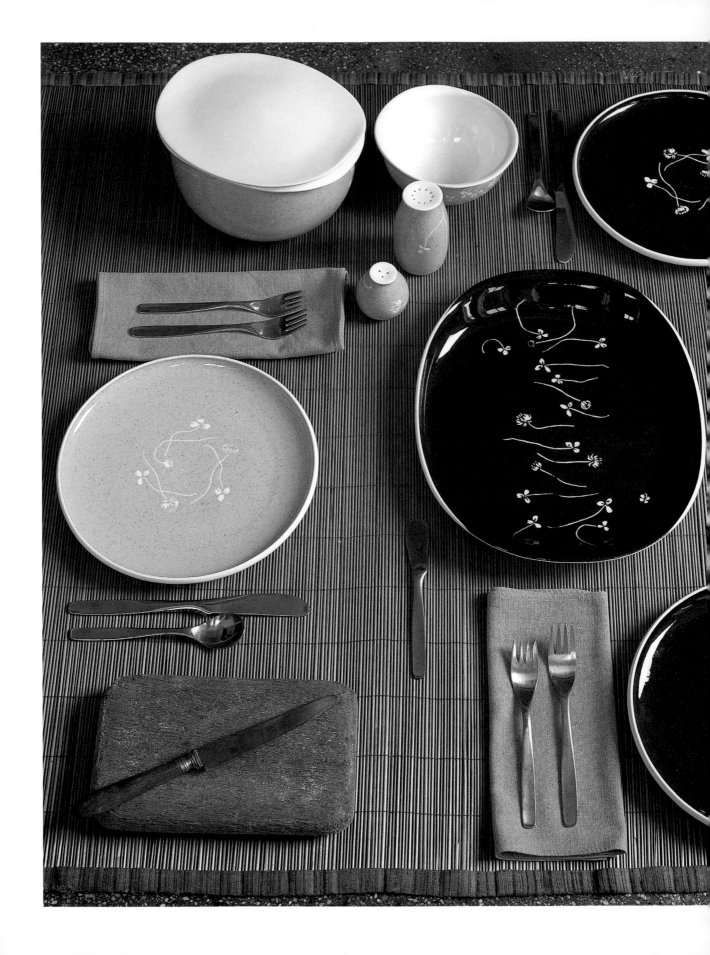

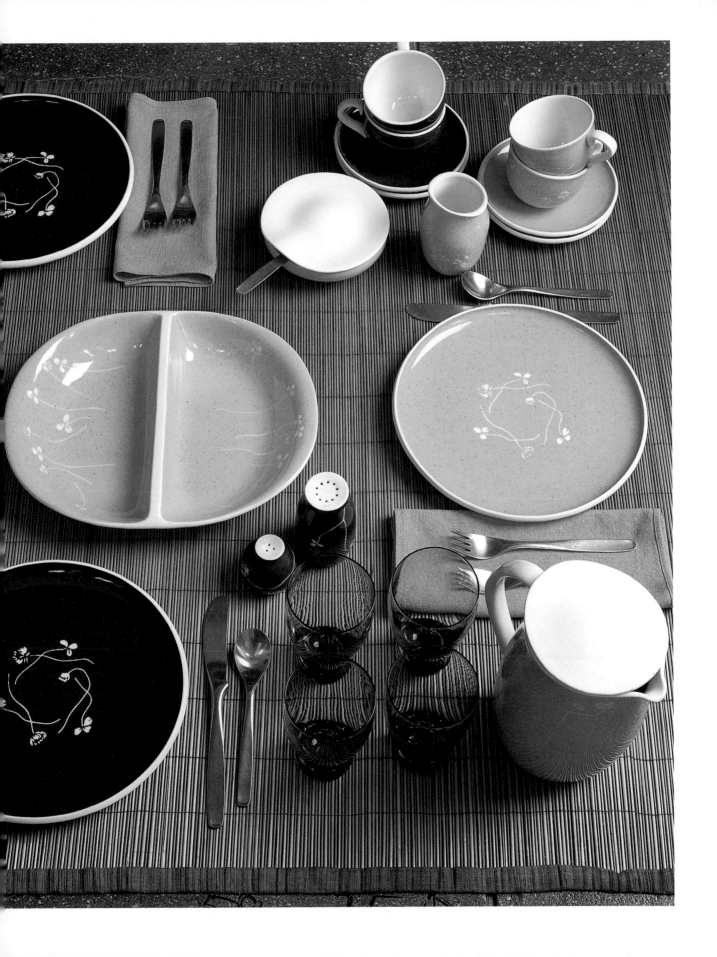

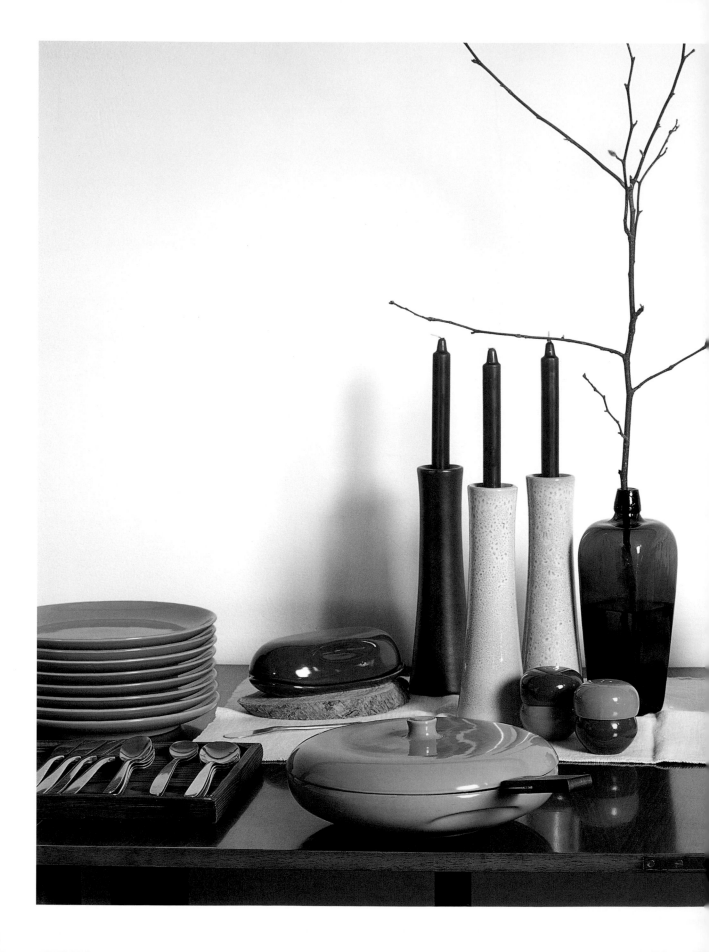

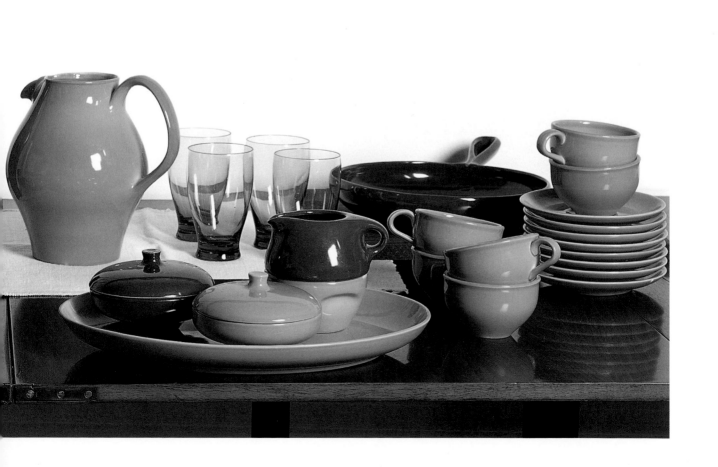

Country Garden Cream and Sugar

previous pages: **Buffet Dinner**

Salt and Pepper Curves

"Certainly more than a few of today's many frustrations and guilt complexes, as well as family failures, have their roots in the struggle to fit our twentieth-century selves into an eighteenth-century corset." —*Guide to Easier Living*

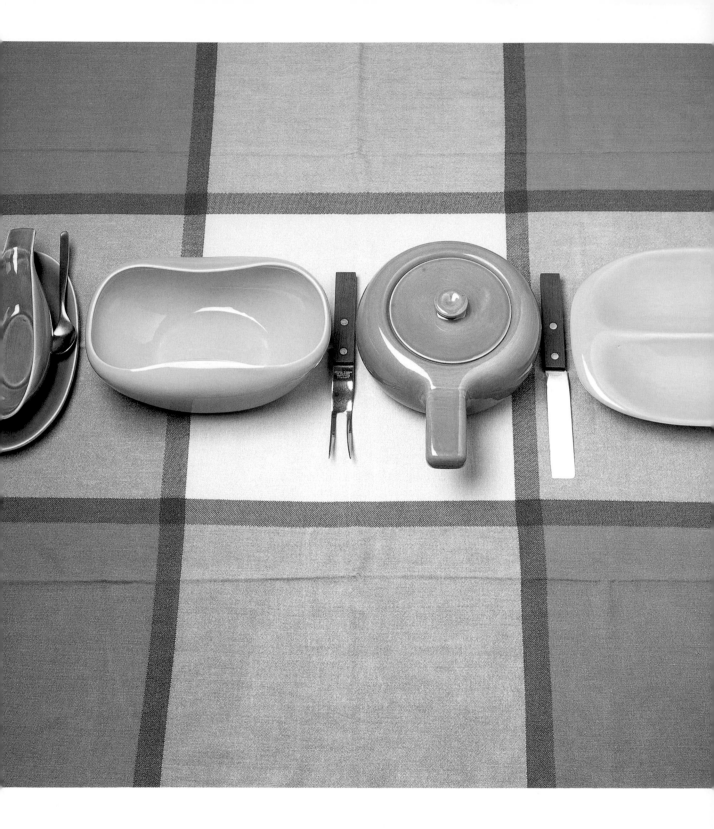

Family Cafeteria table from Guide to Easier Living (see page 49 for a description)

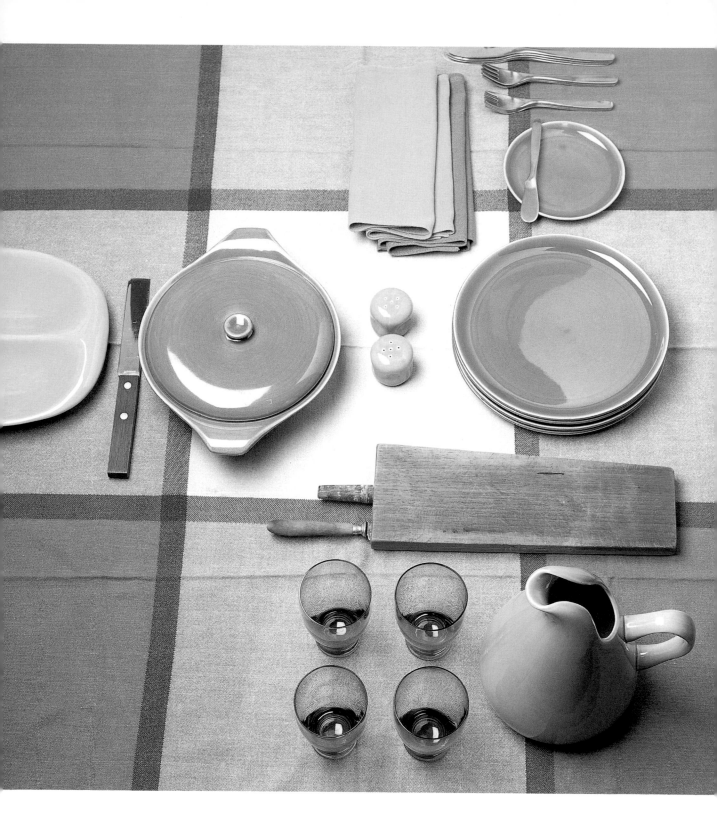

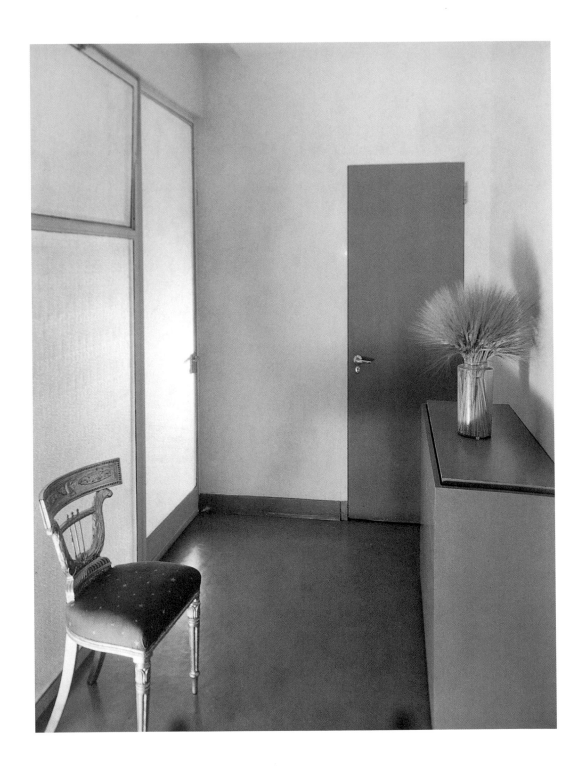

Foyer, Wright apartment, Concord Apartments, East 40th Street, New York, ca. 1937

FROM HOLLYWOOD
TO WALDEN POND

stage sets for american living

Donald Albrecht

Designing stage sets for the American lifestyle came naturally to Russel Wright. New York City's glittering avant-garde theater world beckoned alluringly to the seventeen-year-old freshman bored by Princeton's quiet halls, and he never looked back. Born and raised in provincial Lebanon, Ohio, Wright gravitated to Manhattan just as the American theater was on the verge of a revolution. A new generation of playwrights, directors, and designers who broached taboo subjects and elevated set design into modern stagecraft nurtured his ambitions to become a set designer.[1] But by the end of the decade, after working with Norman Bel Geddes and George Cukor, Wright's lack of success in his own right prompted his creative turn from sets for the theater to sets for the American home.

Although Wright gave up a career in the theater, he never really abandoned the stage. From the 1930s through the 1960s, Wright translated his background as a jazz-age stage designer into interiors that were carefully orchestrated backdrops for modern American lifestyles. Just as he would later dramatize food with his dinnerware, Wright would dramatize life with his interiors. Collaborating with his wife, Mary, the team's marketing genius and Russel's partner in conceiving their "easier living" philosophy, Russel designed settings for new, informal lifestyles that encompassed a full range of decor, from furniture to tableware. He even remained faithful to the discipline of the script: the Wrights' style guides offered readers fully rendered scenarios prescribing how to live in their modern "democratic day."[2] And like a play itself, Russel Wright's career may be considered a three-act odyssey of self-realization, as the designer transformed himself from urban trendsetter to suburban guru and, ultimately, rural nonconformist.

Caricature mask, probably John Barrymore, mirror, paper, and metallic yarn, ca. 1929

The setting for Act I was Depression-era Manhattan. After marrying Mary Einstein in 1927, Russel launched into designing exhibitions, showrooms, and restaurants that broadcast his distinctive modern aesthetic to a wide audience. He designed three apartments for himself and Mary, evolving from Hollywood moderne to Bauhaus functionalism to organic modern.

Act II took place against the backdrop of a prosperous, postwar America. The Wrights crystallized their concept of a new informality—first in their 48th Street townhouse, which served as a laboratory for their ideas on casual elegance and daily life taken outdoors, and later in their celebrated book, *Guide to Easier Living*.

Finally, the curtain rose on Act III with Mary's death in 1952, which left Russel a single parent of their two-year-old adopted daughter, Ann, and without Mary's marketing flair. In subsequent years Russel turned increasingly introspective and away from commerce—a transformation that culminated in Dragon Rock and Manitoga, his house and landscape near New York City. After proselytizing self-realization for decades, Wright gave form to his own manifesto in creating one of the most idiosyncratic homes in America. From the dining room table, which overlooks a man-made pond and waterfall, to the carefully sculpted landscape beyond, the estate rippled outward in a physical echo of Wright's career itself. Dragon Rock and Manitoga, like a modern-day Walden Pond, also reiterated a characteristically American call for individualism in an increasingly conformist age.

Wright apartment, showroom, and workshop, East 35th Street, New York, early 1930s

Act I: 1931–1942 *Scene I: Hollywood Moderne*

Russel Wright's transition from theater to home began with small steps. After returning to Manhattan from working with stage director George Cukor in Rochester, Russel designed life-size caricature masks of celebrities such as Greta Garbo, Herbert Hoover, and John Barrymore and miniature circus animals modeled on the props he did for the Maverick Theater in Woodstock, New York. The avant-garde magazine *New Review* published the masks and high-end Manhattan gift shops successfully sold his circus animals.

The stage would influence Russel's aesthetic approach. Theater, Wright's biography noted, marshaled "all of the crafts; it teaches…a special sensitivity to texture and color as [the designer] seeks to establish a mood whereby the emotions of the stage are transmitted to the audience."[3] Russel applied the same attention to "establishing the mood" to modern domestic life. Used together, his dinnerware, furnishings, and

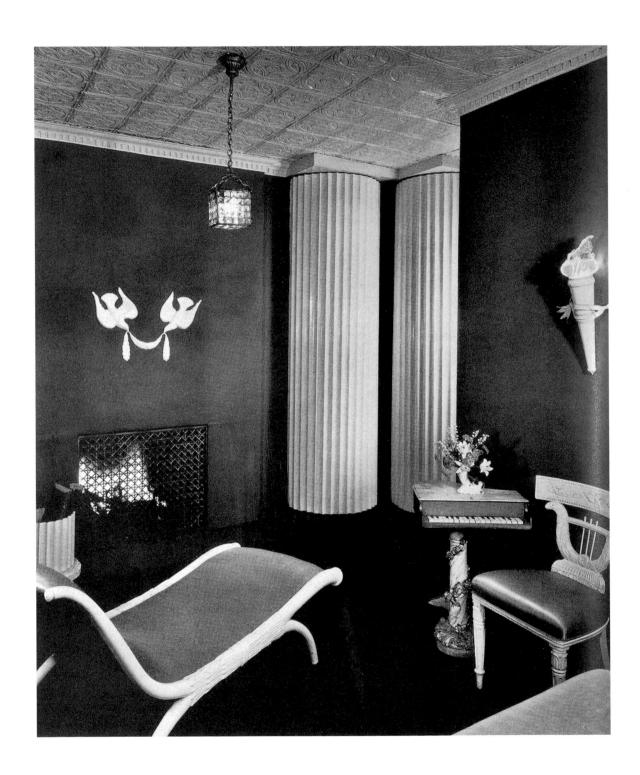

Bedroom, Wright apartment, East 35th Street, New York, 1934

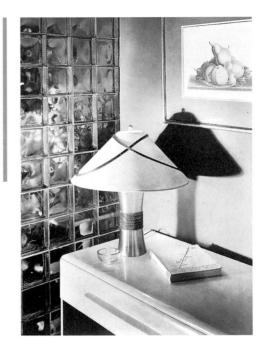

Raymor lamp and American Modern side table, ca. 1935

A glass block wall and copy of Frank Lloyd Wright's autobiography provided suitable modern decor for Wright's lamp and table.

principles of interior design could produce homes that "join the emotional, sentimental and esthetic characteristics with the practicality and comfort that we have created in the twentieth century."[4] The theater's work-intensive environment also prepared him for the new field of industrial design. "The curtain had to go up on opening night and the production had to be finished."[5]

Wright brought the theater home in the scenographic style of interior design he adopted in his residence at 165 East 35th Street, where he and Mary moved in 1931.[6] This former stable was the first of many living-cum-working spaces the Wrights would inhabit. Russel converted its top floor into an apartment and the two lower floors into a showroom, manufacturing workshop, and shipping department for the couple's first line of spun aluminum serving pieces.[7]

To attract attention for their new venture, Wright painted the exterior of the building in American colors of dark blue with white and red trim. The stylish studio lured many fashionable figures, from Broadway star Clifton Webb to arts patron Mrs. Chester Dale. The Wrights' private quarters were equally theatrical. An interior palette of red and white or brown and white produced bold, graphic effects. Already, Wright was mindful of how the tiny apartment would reproduce in black-and-white photographs, such as those later published in House Beautiful. Movie designers of the time achieved similar effects through similar means. Another nod to dramatic conventions was Wright's manipulation of scale—massive, fluted columns housed bedroom closets. Further tipping their hat to Hollywood, the Wrights made a short film of the apartment

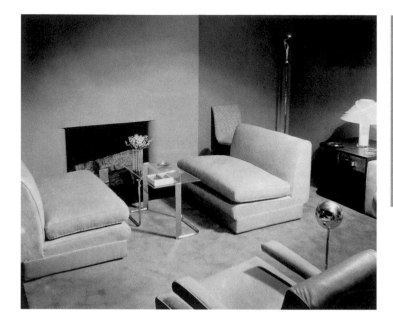

starring Mary, appearing like Jean Harlow, as the embodiment of a fashionable lifestyle of sexual freedom, luxury, and glamour. Mary gave viewers a tour of the apartment in a slinky, low-cut gown, fixing her makeup in front of the built-in vanity and lounging seductively on the bed.[8] (The analogy to Harlow is especially apt: in her article "What is Swedish Modern?" of about 1933, Mary distinguished Swedish modernism from "American modern" by comparing Greta Garbo to Jean Harlow.)

Scene II: *Bauhaus Interlude*

The inauguration of President Franklin Delano Roosevelt in 1933 created fresh opportunities for designers in America. Determined to signal a new deal for the economically depressed country, FDR spearheaded the repeal of Prohibition, passed in 1919, as one of his first administrative achievements, giving "stimulus," in the words of Architectural Forum, "to new ideas of design and…a new spirit of gaiety and life to decoration."[9] Designs for an up-to-date bar—sleek and modern—were suddenly in great demand, and such sophisticated designers as Warren McArthur and Holabird & Root entered the field. Wright went them one better: he designed not only the bar—midtown Manhattan's Durelle Tea Room—but also the spun-aluminum cocktail set that perfectly suited its chic mood.[10] The bar's stools, like Wright's Informal Serving Accessories, wrapped metal in warm rattan accents. This synthesis of product design and architecture would characterize Wright's work for the remainder of his career.

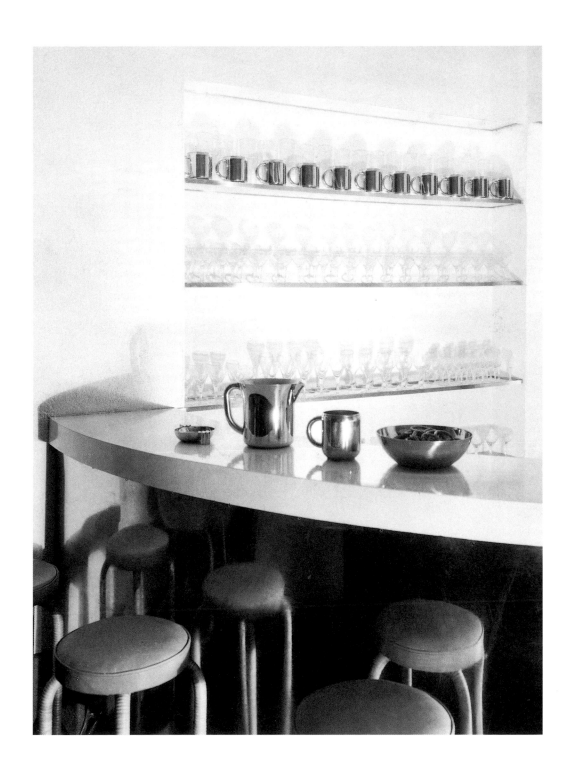

Bar, Durelle Tea Room, Madison Avenue, New York, 1933

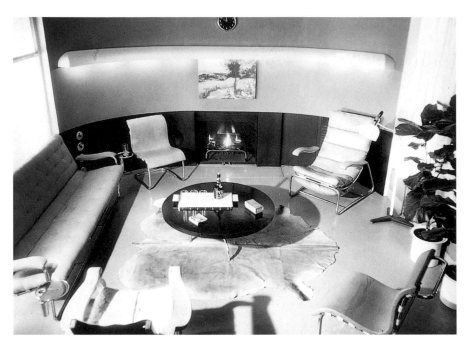

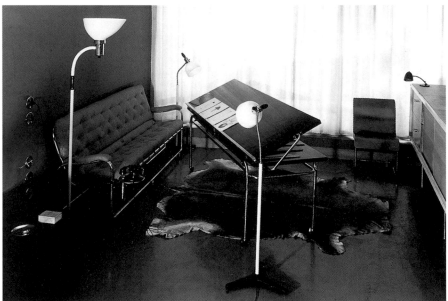

Living room, Wright apartment, Concord Apartments, East 40th Street,
New York, ca. 1937

Dining room cum studio, Wright apartment, Concord Apartments, East 40th Street,
New York, ca. 1937

The Durelle Tea Room was one of many new designs presenting the ideas of a vanguard, machine-inspired International Style in architecture. The Museum of Modern Art's influential 1932 exhibition *Modern Architecture* promoted the work of such European architects as Ludwig Mies van der Rohe and Walter Gropius, two former directors of the Bauhaus, the revolutionary German design school. Owing a debt to American architect Frank Lloyd Wright, these modern architects promoted open, fluid plans of interlocking spaces. Russel Wright employed this new spatial approach in the showroom he designed in 1933 for Mary Ryan, his sales representative for the Informal Serving Accessories line. A contemporary statement on the showroom's design clearly signaled Wright's desire to move beyond stagecraft into architecture. "By modern display," the release said, "we do not mean simply a 'décor' harmoniously in keeping with modern merchandise, but a new type of architectural display background, as instrinsically new in theory as modern merchandise itself."[11]

When *House Beautiful* magazine reviewed the Wrights' 35th Street apartment after the opening of the Mary Ryan showroom and the Durelle Tea Room, they noted how its decorative historical pastiche was not "in character" for a machine-age convert like Russel.[12] Redress came in the form of the Wrights' new penthouse apartment at the Concord Apartments at 130 East 40th Street, to which they moved in 1937. Its Bauhaus-style functionalism announced Wright's starring role on the new stage of industrial design—alongside Raymond Loewy, Henry Dreyfuss, and former mentor Norman Bel Geddes.[13] Metal tubular furnishings, gooseneck lamps, and a sofa with cantilevered end table shone within the apartment's light gray walls, rubber-tiled floors, and exterior

Winter Hideout in the Adirondacks installation from the new York World's Fair, 1940

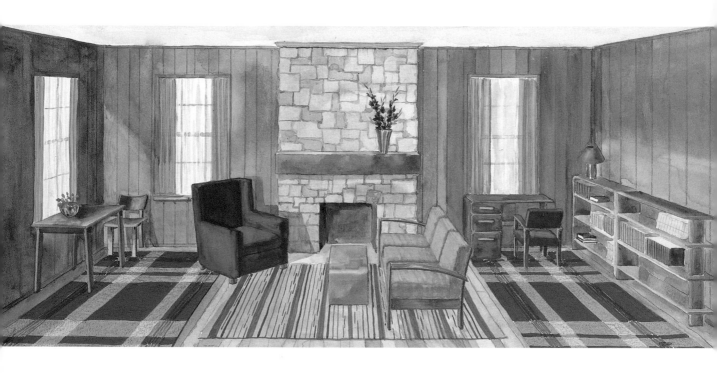

Renderings of American Modern furniture demonstration rooms at Macy's,
New York, graphite and watercolor on board, ca. 1935

Wright's demonstration rooms—one traditional, the other modern—showed
potential customers that American Modern furniture could fit within different
domestic styles.

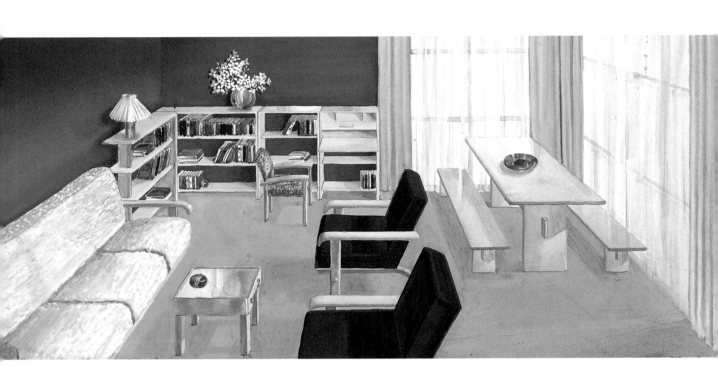

glass wall. Multifunctional furnishings permitted efficient multipurpose rooms. For example, the Wrights' dining table (in black Micarta, a fashionable plastic laminate) converted to a display stand and easel for Russel's client presentations.[14]

Wright offset the home's modern furnishings with an animal skin rug, his Cowboy Modern armchair, and a neoclassical chair from the 35th Street apartment, which he placed against a backlit glass wall for maximum theatrical effect. Such studies in contrast, which would increasingly characterize Russel's interiors, telegraphed an important message to his Depression-era audience: "going modern" did not require discarding vintage family heirlooms and buying all new furniture. Modernity and tradition could happily coexist.

Scene III: *American Ways*

The imported Bauhaus style of the Concord apartment was just a waystation for Russel Wright. Throughout the 1930s—in the Wrights' third apartment, as well as in exhibitions, demonstration rooms, and other media projects—he moved away from what he described as his rigid "T-square and compass period" to a mature aesthetic of curvilinear shapes fused with warm, natural materials favored by Colonial Revival designers.[15] As early as the 1876 Centennial, Americans began looking to the simple, thrifty values of the nation's past as an antidote to rapid industrialization and modernization after the Civil War. New impetus was given to Colonial Revival in 1924 with the opening of the Metropolitan Museum of Art's American Wing in New York and the

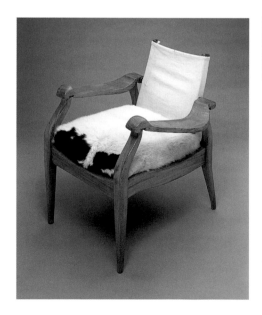

Cowboy Modern chair,
wood, painted vinyl,
ponyskin, metal, 1932

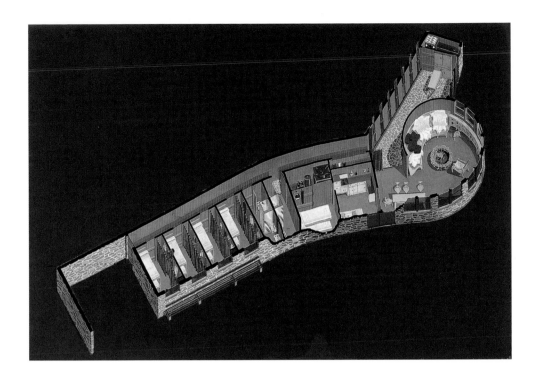

1926 launch of the restoration of Williamsburg, Virginia, tempo-
rary seat of the nation's colonial government. The social and
economic upheavals of the Depression only served to enhance
the country's desire for a return to a seemingly innocent past.

Wright's interest in America's historic roots was manifested
in several furniture designs produced in the 1930s: the Cowboy
Modern chair and the successful 1935 American Modern furni-
ture. Conant Ball promoted the simple, wood furniture with a
nine-room Modern Maple House, which Russel designed for
Macy's flagship store on Herald Square. "In presenting Russel
Wright's American Modern," Conant Ball's marketing literature
proclaimed, "[we] have...continued and modernized a century-
old tradition. For American Modern is the logical, present day continu-
ation of native American furniture design."[16] At Macy's, Russel fash-
ioned an all-inclusive decor for modern American living that
combined Wright-designed furniture, lamps, and accessories.[17]
The nine rooms offered a menu of different decorating styles,
all of which were compatible with American Modern furniture.
Wright's catholic definition of modernism was suitably and
shrewdly geared to popular taste. These settings at Macy's were

Drawing, gouache on board, probably 1930s

This surreal drawing for an unnamed project from Wright's office depicts women in a circus setting, "taming" sewing machines and other domestic equipment. The use of vignettes and dioramas relates it to Wright's design for the *Food Focal* exhibition at the 1939 World's Fair.

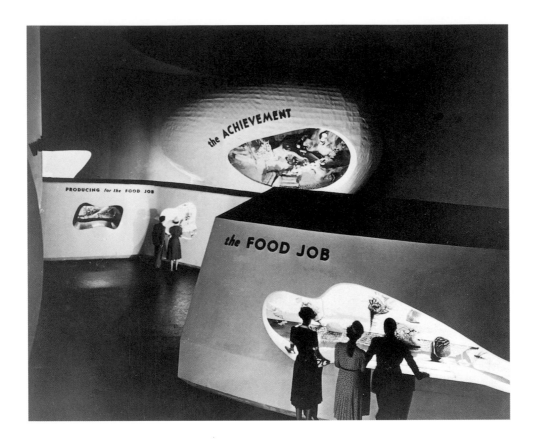

Food Focal exhibition at the New York World's Fair, 1939

among the earliest rooms of mass-marketed contemporary furnishings, an important step in Wright's conception of the domestic interior as a holistic ensemble.[18] Wright would use such demonstration rooms in future campaigns for other lines of furniture and accessories to establish a modern "mood" for contemporary living.

The curvilinear shapes of Wright's new aesthetic were largely inspired by the work of the Surrealists, particularly Jean Arp and Joan Miró.[19] The Surrealists' emphasis on individual imagination and dreams rather than rational thought attracted an independent like Wright, while their use of biomorphic forms was alluring as an alternative to the "T-square" aesthetic Wright had recently rejected.

Wright's 1939 ski club project for Esquire magazine demonstrated his interest in creating an architectonic biomorphism. "Realizing that talking ski before an open fire is the pleasantest part of the sport," the magazine noted, Russel "drew up a circular

fireplace…[where] skiers may loll on the reclining bench, made soft by padded sheepskins and leather pillows."[20] The fireplace nook's protective forms and comforting materials were not unlike the undulating shapes and sturdy weight of American Modern dinnerware, which Steubenville introduced with great fanfare later that year, and Wright's "outdoor living room" at the Metropolitan Museum of Art in 1940.[21] Perhaps for many Americans, tottering between economic depression and world war, such spaces promised a safer world than the one they knew.

Wright's design for the Food Focal exhibition at the 1939–40 New York World's Fair harnessed "Surrealism to tell an educational story."[22] Wright's acknowledgment of the pavilion's roots in Surrealism came a few years after the movement had migrated from the art gallery to the magazine page, fashion salon, and department store window. Salvador Dali's shocking pink sofa (inspired by Mae West's lips) furnished the Paris salon of couturiere Elsa Schiaparelli, whose Pavillon d'Elégance at the 1937 Paris Exposition Internationale appeared in Harper's Bazaar.[23] In 1939, Dali created a notorious Surrealist window for

Demonstration room at R. H. Macy's for American Way, New York, ca. 1940

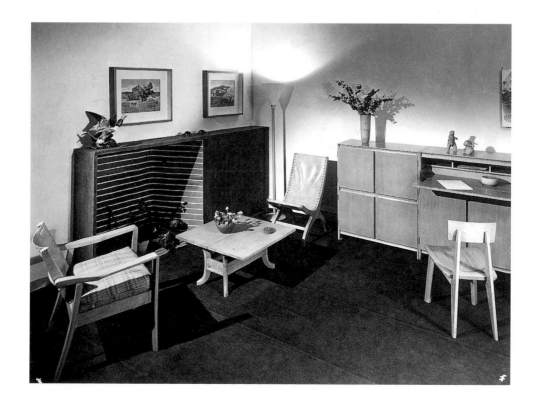

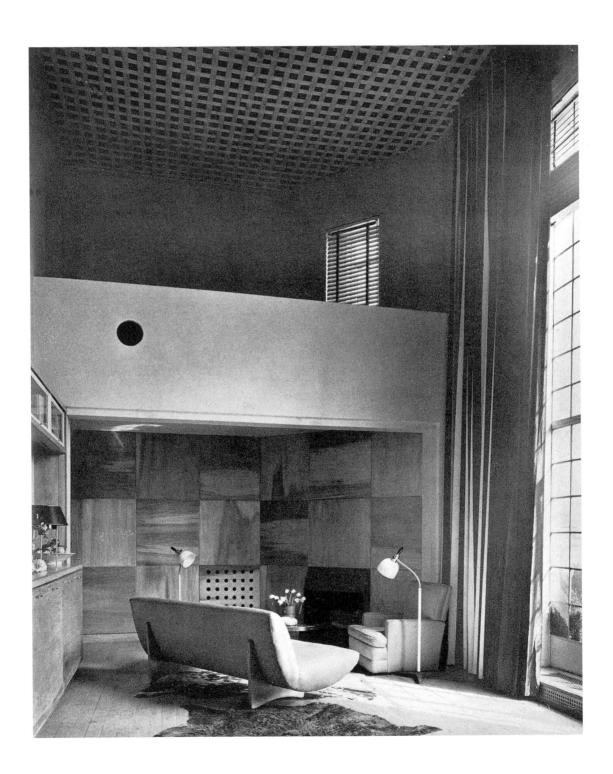

Living room and balcony office, Wright apartment, Park Avenue, New York, 1943

Manhattan's Bonwit Teller. At the New York World's Fair, Wright, in the spirit of Dali, designed dreamlike dioramas that showcased advances in American food production and distribution. His free-form windows and ovoid display cases evoked the shapes of his wooden Oceana serving pieces. The exhibition also featured a flight of winged lobsters, a reference perhaps to Dali's lobster telephone (1936) and a dress printed with lobsters and designed by Schiaparelli with Dali (1937). Wright would continue to draw on Surrealist influences in his work but would never again use them on such a grand and theatrical scale.

Instead, the Wrights returned to their interest in a characteristically American manifestation of the domestic scene: a cooperative venture between designers, crafts-people, manufacturers, and retailers called American Way. Designers and artists as diverse as Henry Dreyfuss, Norman Bel Geddes, Eliel Saarinen, and Grant Wood were to participate. As European countries were drawn into the war against Germany, American designers like Wright saw an ideal opportunity to step out from Europe's design shadow and create an "American" style. Wright's launch of the campaign included room settings at Macy's Manhattan department store. In the rooms' integration of furniture, draperies, lamps, and decorative objects by number of designers, Wright was visually proving that the "program offers us unity with freedom to make our own choice—The American Way!"[24]

Wright's concept of "craft modern" was the theme of his Winter Hideout in the Adirondacks, an installation featured at the second year of the New York World's Fair. Accessorized with hunting gear, sports equipment, a moose skull, as well as Wright's Cowboy Modern chair, the interior highlighted rugged materials, natural textures, and structural forms, in anticipation of the aesthetic Wright himself would use years later in designing Dragon Rock. At the Winter Hideout Wright fostered an illusion that "one has happily come upon a boulder formation on an uncultivated location."[25]

At the end of this period, Wright explored an organic modernism in his new triplex penthouse apartment at 7 Park Avenue, where the Wrights moved in 1942. "Russel and Mary Wright, industrial designer and business associate respectively, artists and anti-disciplinarians jointly," Interiors magazine wrote in 1943, "added a congenial home to the work they enjoy by blending both these important divisions of living into a simplified whole."[26] Articles on the Wrights' apartments often illustrated their separate, differently decorated bedrooms, which served to emphasize their professional relationship over their married one and to showcase the taste range possible within the easier living life-style, even within the same family.

Wright's stylistic explorations during the 1930s coalesced in the new apartment. Flanked by terraces on two sides, the triplex featured sleeping quarters on the first floor, living rooms on the second, and a balcony office on the third floor overlooking the living room. The simple, wood-paneled walls were essentially architecturally scaled

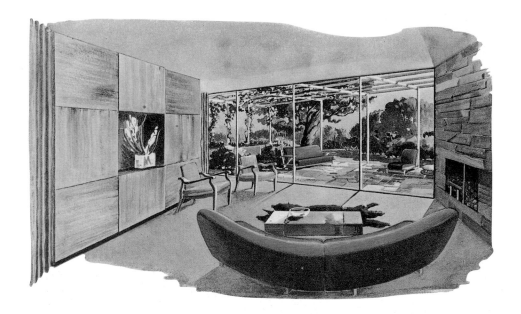

versions of an American Modern chest of drawers, the sofa rounded like an American Modern pitcher. Like Schiaparelli, who made plastic insects into jewelry, Wright turned a medical model of a human ear, with labeled and removable parts, into a lamp base that possessed, according to Interiors, "unique decorative value."[27]

The Park Avenue apartment marked a watershed in Wright's thinking about the home. Warmer and more hospitable than the previous residence in the Concord, the Park Avenue apartment suggested the move toward the casual and gracious postwar concept of "easier living."

Act II: Easier Postwar Living, 1942–1952

The Wrights moved to the Park Avenue apartment during World War II, when the country was focusing its attention on military efforts. But optimistic forecasts of victory soon ignited an explosion of commissioned "house of 194x" proposals for the anticipated return of veterans and their families. As early as September 1942, Architectural Forum featured thirty-three futurist projects. In contrast to revolutionary ideas for standardized and prefabricated housing by such architects and firms as Skidmore,

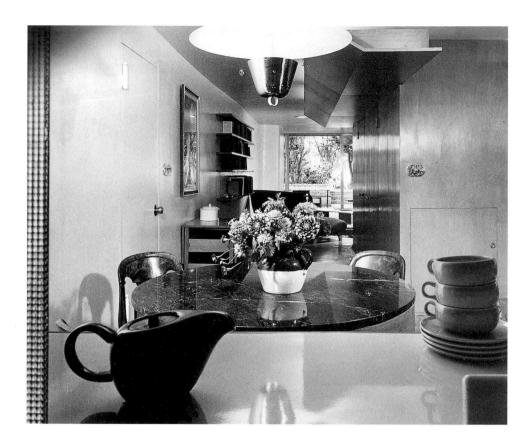

Owings & Merrill and Richard Neutra, Russel and Mary Wright cautioned an evolutionary design approach, keeping, in their own words, "somewhat within the possibilities of the near future." Their concepts for a multipurpose bedroom nightstand, adjustable dressing table, and compact closet began the process of modernizing the bedroom. "It is expected," they wrote, "that we will begin by improving existing furnishings, eventually evolving a more radical approach and a more integrated whole."[28]

Two years later, Russel presented just such an integrated design. In a *Better Homes and Gardens* article, he joined architect George Kosmak and decorator Alfons Bach, fellow "forward-looking realists," to predict "the workable stuff...[to] plan your postwar house."[29] A low, freestanding partition in Wright's "gardened living-room" of a suburban house allowed an open flow between the room's social and study areas. Concurrent with George Nelson and Henry Wright's "storagewall," Russel Wright's paneled partition held dishes and glassware, a movie projector,

Wright residence, view from kitchen pass-through toward dining room and living room, East 48th Street, New York

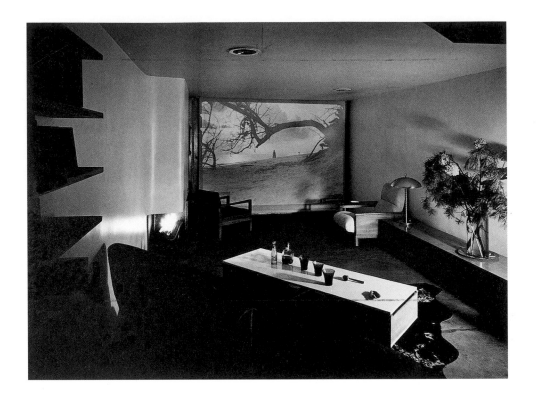

Wright residence, view of living room looking toward garden with projection screen in front of window, East 48th Street, New York

card tables, and games.[30] The center section of the wall was open for pass-through service of cocktails and buffet suppers. (Wright's "radio-television" coffee table with drawers for records was an early example of the postwar craze for "entertainment centers.") The entire space looked out to the garden via an insulated glass wall, which could be rolled open. The living room and garden also shared fireplaces. In its spatial openness and advanced technology, Wright's design was a template for his own concepts of postwar easier living—the shape of domesticity to come.

After the war, the Wrights continued their explorations into modern domestic living. In 1946 they moved to a four-story brownstone at 221 East 48th Street, which contained working and living spaces for the Wrights along with rental apartments. Off the back of the ground floor, Wright added an S-shaped extension housing drafting tables and a built-in desk. (Built-in units would be mainstays of the easier living lifestyle.) Not unlike American Modern dinnerware, the curve of the windows was beautiful yet practical because it afforded more light than

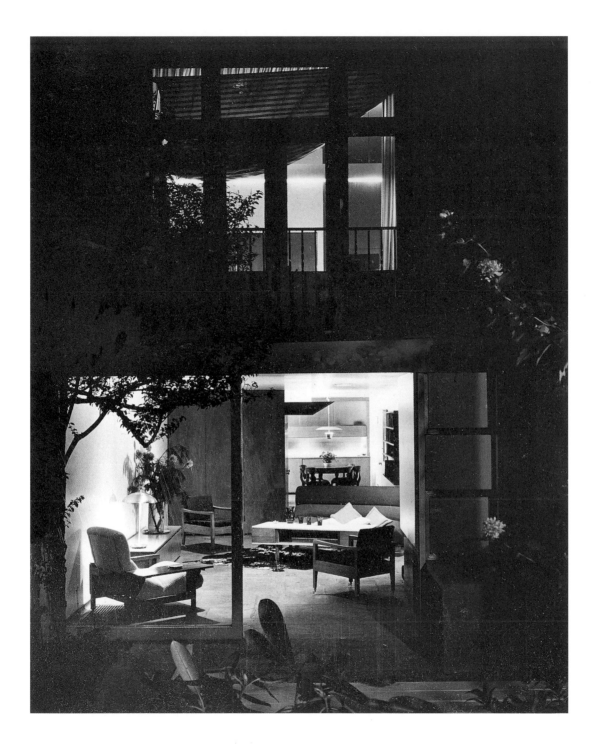

Wright residence, view from garden into living room (with dining room and kitchen beyond), East 48th Street, New York

Inside the book illustration:

The Bedroom for a Single Adult: This is not actually a separate problem. Basic principles of planning and furnishing are the same here as for the master bedroom, with less space needed for sleeping and dressing-storage areas and more for leisure. This is an extremely personal room; its character is determined by whether its occupant is an elderly relative, a grown son or daughter, or a guest rather than a permanent resident.

What, No Victorian?

5. We can well imagine the headshaking of many readers as they go through these pages—because for many generations the bedroom has been considered the sentimental core of the home, and, through the dictates of fashion and etiquette, has become a veritable Valentine chock-full of all the feminine goodies, the classic models being the Victorian, Colonial, and French bedrooms so popular today. It is for this reason that we pause briefly here to argue and amplify the aesthetics of our case.

If you are so enamored of the charm of other centuries that you can stand the gruesome, tawdry look of such rooms each morning and then do the work of other centuries to restore order—then have such a room. But if you really want to save work, and to have a room that properly fulfills its intended functions, you'll have to give up your dreams of living in another age and enjoy your own twentieth century.

Of course, in a room as personal as a bedroom, the occupants' personality should be expressed. And, if designed and planned properly, the simplified interiors prescribed here can serve as a flattering background to set off dramatically and effectively whatever personal touches you want. Your favorite pictures can be hung on one wall, or your favorite collection (old coins, or shells, for example) kept under glass. New coated fabrics and wall coverings enable you to surround yourself with favorite colors.

Perhaps you will have to change your ideas of charm and beauty. After all, there are lots of different kinds—Georgian and Victorian are only two brand names.

The bedrooms illustrated in this chapter are devoid of traditional furnishings . . . yet they possess qualities of charm, dignity, and a serene kind of beauty that cannot be found in traditional rooms. Learn to enjoy them.

Caption in illustration (left page): None of the traditional heart-warmers—no canopied bed, delicate night table, fluffy lamps, skirted vanity, drapes, valence, or tie-backs—and yet we consider this classic of modern design by architect Richard Neutra the most beautiful bedroom we have ever seen.

66 67

Richard Neutra–designed bedroom illustration from Guide to Easier Living, 1950

a standard window as well as panoramic views of the garden. In time, a glass-paneled pass-through separated the dining room and kitchen, and a storage wall and desk were installed in the living room. Furniture was on casters for easy mobility, and a window blind formed a projection screen for home entertainment.

The 48th Street house served as the Wrights' real-life laboratory for testing ideas for *Guide for Easier Living*, which distilled their thinking on domestic life. The book's 1950 publication coincided with a period of soul-searching in the United States. More than fifteen years of depression and war had caused economic and psychological dislocation. Military victory brought power and prosperity, thrusting Americans into an international spotlight. Postwar commentators, ranging from popular journalists to historians and sociologists, sought to understand the character of the modern United States.[31] In 1948, behavioral psychologist B. F. Skinner published *Walden Two*, a utopian novel that urged cooperative living in a spirit of "industrialized housewifery."[32] *Guide to Easier Living* echoed these themes, but presented them in an instructional, rather than fictional, format.

As part of the campaign to define the nation's contemporary life, design professionals helped shape American taste in the postwar period. Shelter magazines targeted new homeowners. House Beautiful proposed a "station wagon way of life": informal, outdoorsy, easy to maintain, and full of vibrantly colored and textured objects that were made by hand or, like Wright's post-war Bauer pottery, appeared to be handmade.[33] The station-wagoners no longer needed Europe as a design source: Frank Lloyd Wright had proven the superiority of native talent. Instead, readers were encouraged to choose contemporary American furnishings, which they could combine with an eclectic array of decorative objects and craft products to personalize a comfortable contemporary home.

Museums and department stores also sought to sell the new way of life. In 1949 the Detroit Institute of Art hosted For Modern Living, an exhibition of domestic products sponsored by the J. L. Hudson department store. The next year the Museum of Modern Art joined with the Merchandise Mart in Chicago to present the first Good Design exhibition, a five-year series of shows displaying hundreds of commercially available domestic products.

Dining-kitchen illustration from Guide to Easier Living, 1950

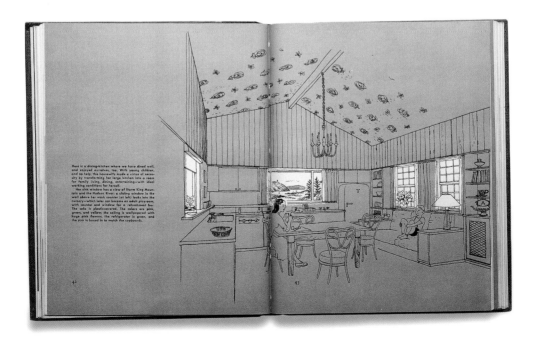

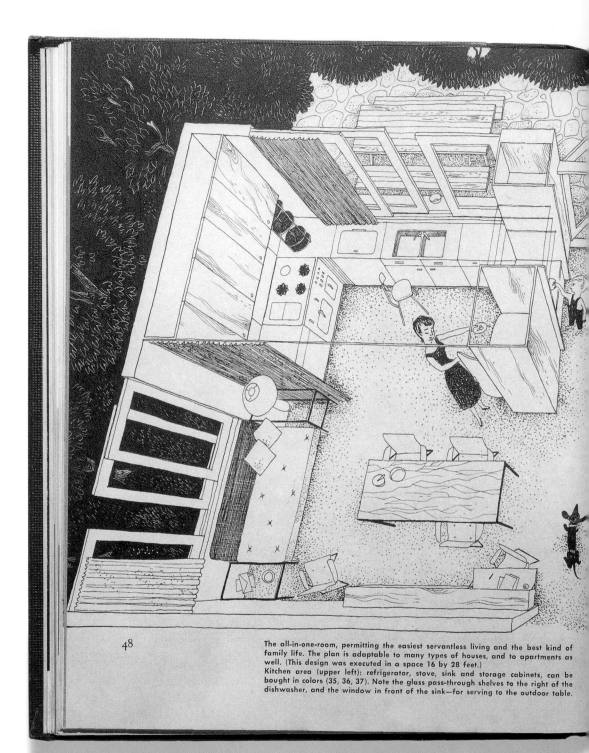

48

The all-in-one-room, permitting the easiest servantless living and the best kind of family life. The plan is adaptable to many types of houses, and to apartments as well. (This design was executed in a space 16 by 28 feet.)
Kitchen area (upper left): refrigerator, stove, sink and storage cabinets, can be bought in colors (35, 36, 37). Note the glass pass-through shelves to the right of the dishwasher, and the window in front of the sink—for serving to the outdoor table.

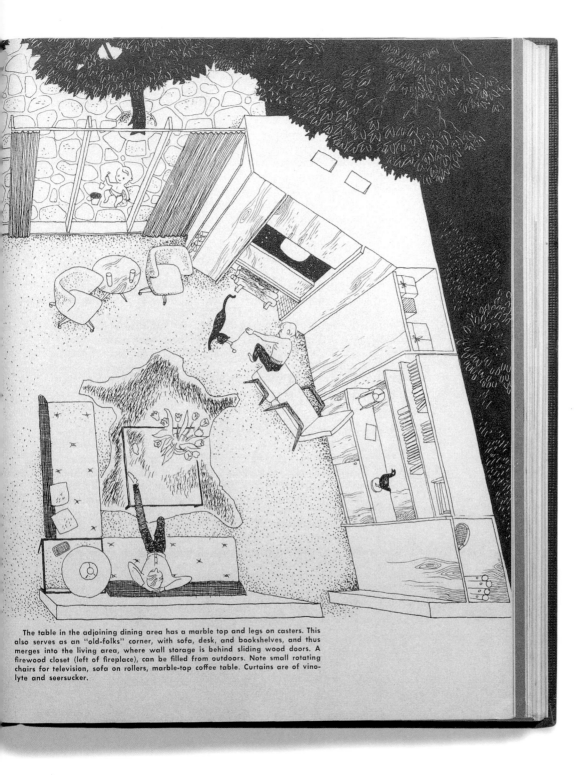

The table in the adjoining dining area has a marble top and legs on casters. This also serves as an "old-folks" corner, with sofa, desk, and bookshelves, and thus merges into the living area, where wall storage is behind sliding wood doors. A firewood closet (left of fireplace), can be filled from outdoors. Note small rotating chairs for television, sofa on rollers, marble-top coffee table. Curtains are of vinolyte and seersucker.

All-in-one-room illustration from *Guide to Easier Living*, 1950

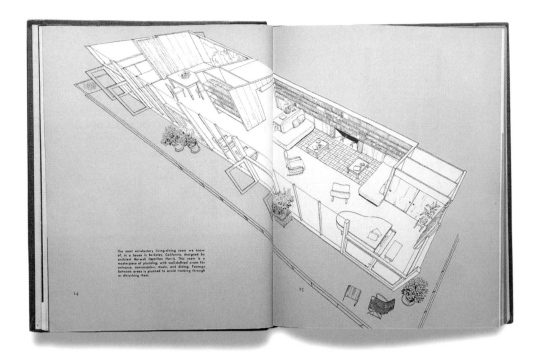

The most satisfactory living-dining room we know of, in a house in Berkeley, California, designed by architect Harwell Hamilton Harris. This room is a masterpiece of planning, with well-defined areas for entrance, conversation, music, and dining. Passage between areas is planned to avoid tracking through or disturbing them.

14 15

Living-dining room illustration of Harwell Hamilton Harris designed house in Berkeley, California from Guide to Easier Living, 1950

Guide to Easier Living was the Wrights' contribution to America's do-it-yourself modern movement. One of its major themes was people's need for comfort and ease. The Wrights urged their readers to discard unrealistic dreams of living like European aristocrats in "baronial" splendor, following rules dictated by such social arbiters as Emily Post. This was especially necessary, according to the Wrights, because of America's recent loss of servants. (In actuality, most middle-class Americans had never had domestic help. Perhaps Mary's personal loss of servants after marrying a poor man like Russel was the real impetus for this concern.)

Unlike such postwar domestic books as George Nelson and Henry Wright's Tomorrow's House and Hazel Thompson Craig and Ola Day Rush's Homes with Character, Guide to Easier Living featured no building exteriors. Instead it focused on interior vignettes—each a different scene in a play of ideal middle-class life, each a different element to be customized to suit homeowners' needs. "We believe the new American home will be a much simpler one to live in," the Wrights wrote. "Its etiquette will derive from modern democratic ideals."[34] Russel and Mary firmly

situated their polemic within the American sociopolitical context as well as postwar corporate society. "In this increasingly mechanized civilization," they stressed, "our homes are the one remaining place for personal expression, the place where we can really be ourselves."[35] The book offered readers an alphabet with which to write their own declarations of independence from convention.

The book's proposed homes for contemporary American families had open plans that flowed casually between kitchens, dining rooms, and living rooms—echoing Frank Lloyd Wright and prophetic of the "great rooms" in many of today's suburban houses. (One chapter is titled "The Vanishing Dining Room.") Furniture was lightweight and easy to move. Materials were effortlessly cared for, like a carpet with "spots" designed into the pattern and building materials with wondrous names like Dex-O-Tex, Sparkle-Crete, and Flor-ever.

Spaces that fostered domesticity and reduced the demands on housewives were a major component of easier living. "We face today an increasing amount of juvenile delinquency, and an annual divorce toll that approaches 25 percent of the marriage rate," the Wrights noted.[36] One solution was to look back to go forward. They praised colonial-era multipurpose farm kitchens and depicted modern versions with sofas so that children could be with their mothers during meal preparation. Eliminating labor-intensive chores also allowed more time for family life, and the book offered numerous prescriptions for easy-to-serve meals, easy-to-clean rooms, and easy-to-make beds. The new informality demanded that husbands help with running the household. The American man, who "has learned to push a baby carriage with pride," the Wrights wrote, "will also learn that it is not beneath his dignity to push a vacuum cleaner."[37]

The book also showcased California as a source for easy, indoor-outdoor living strategies. With its booming economy and mild climate, California solidified its position as epicenter of the American Dream after World War II. The Wrights praised an open-planned, glass-walled house in Berkeley, designed by Harwell Hamilton Harris, and extolled "the most beautiful bedroom we've ever seen," by Los Angeles modernist Richard Neutra. Neutra's bedroom design had elegant built-in cabinetry, exposed wood beams, and a large, uninterrupted expanse of glass offering a panoramic view of nature. Echoes of their American Way project can be seen in the mix of Eames chairs and woodburning stoves, sectional sofas and animal skin rugs. But it was the concept of outdoor living—as illustrated in outdoor dining rooms—that Wright would be compelled to take up in the next act of his career, the retreat to Dragon Rock and Manitoga.

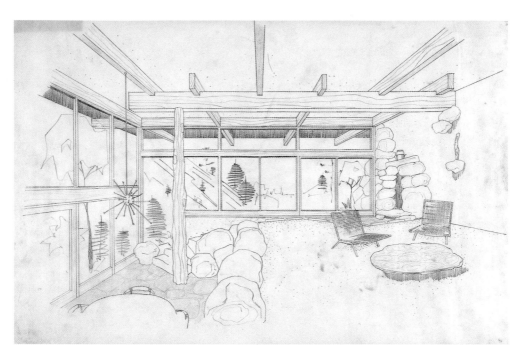

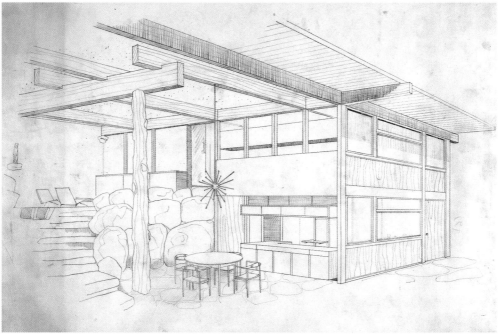

Drawing of Dragon Rock living room, graphite on trace, ca. 1957

Drawing of Dragon Rock dining room, graphite on trace, ca. 1957

Act III: A Domesticated Walden Pond, 1952–1976

Although Russel Wright never fit the standard profile of a 1960s hippie, he lived the decade's sacred mantras by "doing his own thing" and "returning to the land." After a quarter century of trying to persuade the public to follow his plea for individualistic expression, in the 1950s Wright threw off the last vestiges of conformity to create Dragon Rock, one of the era's most unusual residences, and Manitoga, a personal paean to the natural world. Both also conveyed Wright's increasing humility in the face of nature. "No matter what humans may do," Wright learned from visiting a Cambodian ruin while planning the house, "nature can later destroy it and the strength of nature will go on forever and you will be forgotten."[38]

The Wrights first conceived the idea of a weekend retreat for themselves in 1942, when they bought an abandoned stone quarry in Garrison, New York. Throughout the 1940s Russel explored the landscape and studied how to site the house. He could have placed it to have views of the Hudson River and the growing city of Highland Falls. Instead, to achieve total seclusion, Wright nestled the house within the quarry to look out on unpopulated nature.

In many ways, Dragon Rock represented the culmination of Russel Wright's career. It displayed a spectacular array of theatrical "moods" both indoors and out. It situated Wright within the tradition of American artists, like James Fenimore Cooper, who have explored the great national theme of civilization versus nature. "The house must express the idea of the combination of comfortable living that is necessary to the New Yorker as well as his emotional need for the country and for nature," Wright wrote, indicating his romantic notion inspired by Thoreau of an unadulterated nature far from urban influences.[39] Yet, at Dragon Rock, Russel achieved his "natural" effects with remarkable feats of theatrical bravado and Surrealist juxtaposition. He just was not willing to leave nature in its natural state.

Drawing of Dragon Rock entry hall, graphite on trace, ca. 1957

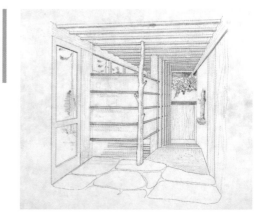

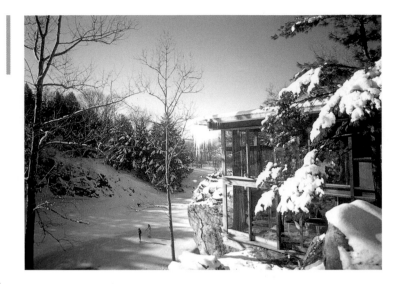

Dragon Rock was Wright's own declaration of independence from convention for himself and his family. In a lecture about the house, Wright told of hearing a woman claim she wouldn't live in Dragon Rock if she were paid to. "Good," the new high priest of nonconformity responded, "let her make up her own idea for living."[40]

The house's theatricality is evident from its approach. Visitors hear a waterfall but do not see it. Like the sound of an orchestra tuning up, it creates anticipation. (This is the first of many references to Frank Lloyd Wright's Fallingwater, which Russel had visited.) Dragon Rock itself is a complex of two volumes—one for family living (including bedrooms for his daughter and housekeeper), the other for Wright's studio and bedroom. Between them is a wooden loggia that Russel draped in a kind of natural stage curtain of vines, seductively veiling the view of waterfall and quarry. Not a licensed architect himself, Wright hired David Leavitt to design the house and create constructiuon drawings. (Leavitt had worked in New York and Japan with Antonin Raymond, a disciple of Frank Lloyd Wright. Russel Wright had sited the house and had definite ideas about its spatial organization and character.)[41] Russel admired the aesthetic of Asian architecture, which Leavitt had used in other residences. Whereas professional architects tend to work from the outside form in, Wright seems to have worked in the opposite direction. The unfolding experiences of moving through the house predominate; the house as a concrete form is secondary.

If, from the approach, Dragon Rock promises, with its paired volumes, a low-slung wood version of the Eames House, the building behind the approach is radically different. The main living space functions as a kind of amphitheater, cascading in stone platforms and steps toward a pond and affording cinemascopic views of nature. Both dining and seating areas curve into the rocks, forming small-scale interior versions of

the quarry. Glass walls and doors lead to stone terraces that serve as outdoor stage sets for barbecuing and lounging. Like a good stage set, Dragon Rock, Russel wrote, was a contemporary residence that was "capable of the variety of moods that can be found in traditional homes."[42]

Everyone at Dragon Rock had their part to play. The female members of the household like Ann and her governess lived in a wing Russel called the "harem," which was entered from a hidden door.[43] While maternal references had been present in Wright's earlier work, from the pregnant shapes of his American Modern pitcher to the womblike conversation pit in his 1939 ski club, they now became explicit at Dragon Rock. Wright used birth analogies to differentiate entrances to the harem: the first, a corridor from within the house, he described as the "natural" way, while the entrance through the garage was "Caesarean."[44] When married couples visited, Wright suggested the husband stay in the studio and the wife in the "harem."[45] While contemporary houses by such architects as Marcel Breuer and Herbert Beckhard similarly separated residential functions into distinct wings, the impresario of Dragon Rock applied his own sexually charged subtext.

Ann was the star of the house. In the spring of 1962, Life magazine celebrated Dragon Rock as an "enchanted world in the woods framed in comfort and beauty." Wright's unconventional house was the perfect setting for eleven-year-old Ann, who lived an equally unconventional life without a mother. A modern-day Becky Thatcher

Russel, Ann, and friends in dining room, Dragon Rock, 1962

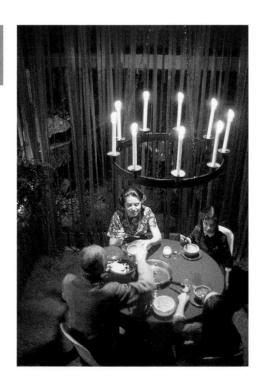

Ann in her bathroom,
Dragon Rock, 1962

exploring the cavelike Dragon Rock with her "ever-present gang," Ann enjoyed child-
hood treats like pulling taffy, hosting sleepover parties, popping corn, and eating
candlelit dinners with unusual foods and settings. She effortlessly operated the "easier
living" chandelier, which was raised and lowered on a pulley for changing the lights.
(The shelf above the kitchen counter could also be lowered to hide dirty dishes.) And
Ann bathed in her own sunken blue-tiled tub with "miniature hot and cold waterfalls"
that overlooked a private terrace and outdoor fireplace. "It has a secret air," one of
Ann's friends recounted. "Being in Ann's house is a little like camping out—except that
everything is comfortable." By focusing on Ann, the article taps into America's
perennial yearning for youth and innocence.[46]

Life magazine told only part of the story. Just as the seeming ease of an actor's
performance obscures the hard work behind the scenes, Dragon Rock's easier living
required precision and planning on an almost military scale. The seasonal scene shifts
were achieved by three people working three days twice a year. Every winter and
summer, they would change the chandelier over the dining table, the curtains, cabinet
door panels, slipcovers, and dinnerware to create a warm winter palette of reds and
oranges and a cool, summer one of lighter tones. All told, the Wrights used innumer-
able sets of dishes over the course of a year.[47]

Wright orchestrated a complex series of blends and contrasts within the house.
"Large expanses of machine-made materials, such as vinyl, fiberglass, etc.," he wrote

Ann Wright and friends in kitchen, Dragon Rock, 1962

Creating the house's dining and kitchen areas required blasting the site's rock.

Russel Wright and friend making seasonal decor changes, Dragon Rock, 1962

Following pages: Dragon Rock seen from the quarry pond, 1999

to the construction crew as they began work, "will dramatically set off pieces of nature that will be brought in as contrast to be visually shocking."[48] Translucent plastic walls were embedded with pressings of local plants and Brazilian butterflies, not unlike the leaves in Wright's plastic Flair dinnerware. Synthetic materials signaled the house's modernity, the yin to its natural stone's yang. (A trip to Southeast Asia in 1955 during the house's planning enhanced Russel's interest in the strong contrasts within Asian culture.) Another reason for the innovative use of plastics may have been monetary. As the original budget for the house rose, Wright asked manufacturers like DuPont to provide materials for his "experimental house." In return, the famous Russel Wright promised to endorse the product in advertisements.[49]

Wright customized many features with elements of the landscape. Hemlock needles from the site were pressed into the living room wall. A tree trunk held up the two-story living room ceiling and became the point from which the plan spiraled like a nautilus shell. Tree branches served as a newel post in the entry hall and a bathroom towel rack. Many of the house's mechanical systems seemed organic: bathtub water magically poured out from rock walls, as did hot air to heat the house.

Nature was put on display outside the house as well. Wright acknowledged civilization by leaving evidence of the site's industrial history. A boulder with a metal hook, for example, decorated the gravel entrance court. Visitors who walk any of the eleven trails that stretch from the house and quarry experience a narrative from the man-made "nature" of the house itself to the woods left untouched on the site's outer edges. Russel intended that each of these trails be experienced in a particular direction, like the forward movement of a play. A short walk around the quarry was constructed to sample all the elements of the site, from stone paths to captivating vistas, thereby serving as overture to the longer trails. Along this route, too, the house finally revealed itself. Neither the overwhelming sculptural force of Fallingwater nor the cool machined aura of Mies van der Rohe's Farnsworth House, Dragon Rock was quiet in the presence of nature.

Dragon Rock and Manitoga's relationship with its environment represented Wright's belief that contemporary Americans must seek to live in harmony with nature. But he made rocks and trees do his bidding. Just as Wright's career extended outward from dinnerware to landscape, Dragon Rock and Manitoga spread from the table to the natural world beyond. Russel Wright's final act was to create a set design out of nature itself.

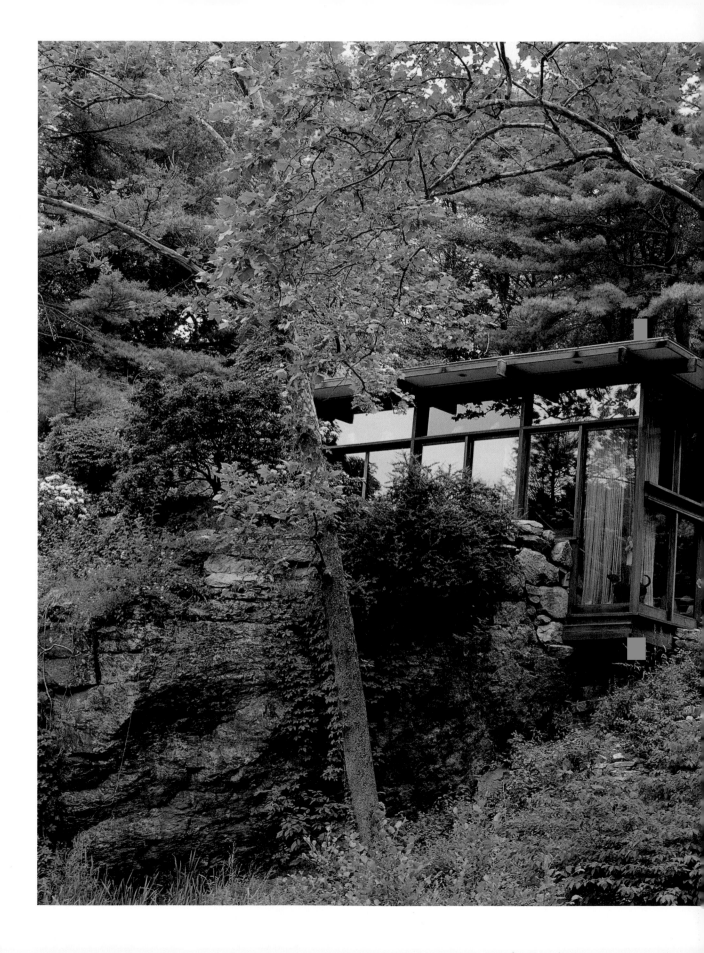

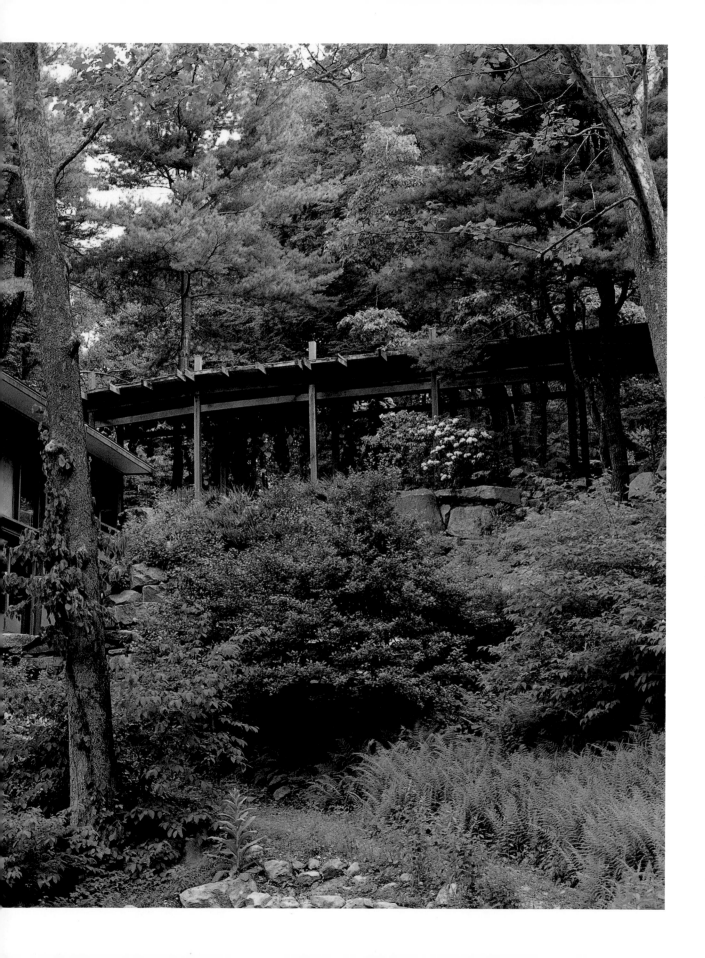

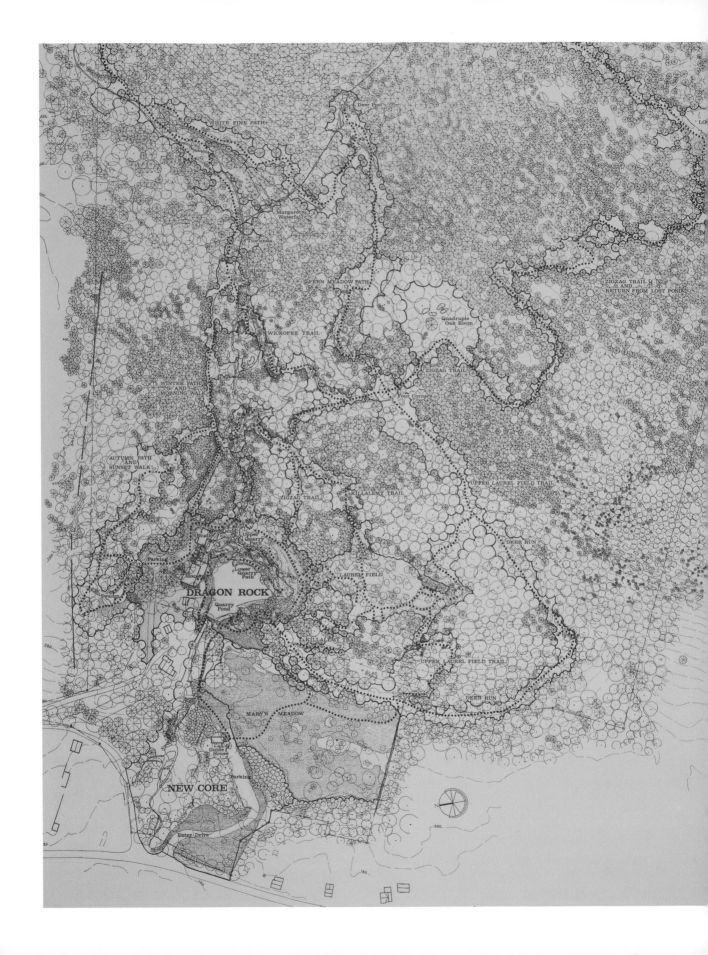

MANITOGA
a modern landscape
in the hudson river valley

Robert Schonfeld

Russel Wright practiced what he preached. The informal lifestyle upon which his professional success was based was also his own personal goal. For Wright, who loved nature and disliked travel, the idea of a nearby second home, a "getaway" from the city, was tremendously appealing. In a letter to the workers who would soon begin to build his new house, Wright wrote, "The house is to be occupied on weekends and vacations…. [I] want it to service [my] need for rest and revitalization from the hard work and sophistication of…weekdays in New York City."[1] From this common desire, Wright embarked on a complex, large-scale, and extremely personal project to build his home, Dragon Rock, and to design the encompassing landscape, Manitoga.

Two historic functions—quarrying stone and logging firewood—had shaped the natural character of the steeply sloping eighty-acre property in Garrison, New York, Russel and Mary Wright bought in 1942. Wright originally considered it a "typical… uninviting dry and impenetrable woods, with no views or vistas."[2] Three abandoned quarries, overgrown with brambles and vines, and a dense second-growth forest were the primary elements that Wright began to transform into the next chapter of the site's man-made history. Working slowly, he began to clear trees and, in his words, establish his ultimate goal of a "garden of woodland paths" to "help people experience the wonder of nature."[3] By the end of his life, Manitoga would comprise the house, as well as waterfalls, a quarry pond, outdoor rooms, and eleven paths, each offering a sequence of unique experiences and views.

Working in a tradition of American landscape most famously advanced in the nineteenth century by Frederick Law Olmsted, Wright reshaped nature. He artfully edited the site to make its forms, meanings, and history clear. Wright did much of the

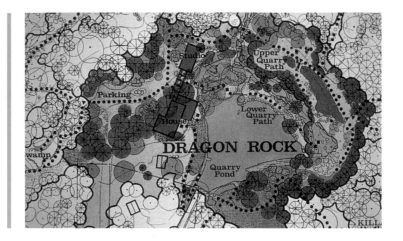

Site plan, Dragon Rock (detail), 1982

Wright nestled the house into the edge of the hill overlooking the quarry pond.

previous page: **Site plan, Dragon Rock and Manitoga, 1982**

This drawing records all the trees, structures, and paths on Wright's eighty-acre property.

work himself over many years, sometimes inviting weekend guests and family to help him in a process similar to the cooperative dinners the Wrights had suggested in Guide to Easier Living. He carefully thinned the forest. Along the paths he created alcoves "to relieve the walled-in effect."[4] Only native plants, such as mountain laurel, wild thyme, and American hemlock, were used. In honor of his wife, Wright created Mary's Meadow, the largest clearing on the property. Stone that occurs naturally throughout the property, which he considered its "most distinctive characteristic," was played up to great effect.[5] Near the house, the stonework clearly resembles steps; farther away, it appears more random, or "natural." Wright diverted one of the site's streams to create a dramatic waterfall that fills the quarry next to the house.

While studying at New York's Art Students League, Wright was criticized by his painting teacher, Kenneth Hayes Miller, for "carving the canvas."[6] At Manitoga, so many years later, he found the vehicle for doing exactly that. By taking away what he did not want and adding native plant material, Wright achieved an important artistic break-through and used his paths to invite visitors into his three-dimensional canvas. His invitation promised an experience that would enliven multiple senses simultaneously—the revelation of being inside a work of art.

As unique as they are, Dragon Rock and Manitoga continue a tradition of Hudson Valley estates that dates to the seventeenth century. The earliest examples were seven-teenth- and eighteenth-century utilitarian Dutch manor houses, such as Philipsburg and Van Cortlandt, which were centered on large agricultural and commercial opera-tions. The first intimations of Manitoga may be found in the nineteenth century at Montgomery Place, where the preeminent garden authority Andrew Jackson Downing acted as landscape planning advisor, and Sunnyside, the home of Washington Irving. One of Downing's goals was to actively involve individuals in the landscape with planned walks and trails, including one to a waterfall. Sunnyside was an American

adaptation of the British picturesque style, which sought to improve upon nature by constructing elaborately romantic landscapes. Wright translated this style at Manitoga into a modern idiom.

At Olana, the extraordinary estate of painter Frederick Church in Hudson, New York, the house sits on a promontory with a grand view of the Hudson River. Church is widely regarded as America's greatest painter of natural wonders that inspired awe and fear. When he returned from traveling to such sites as the Arctic, South America, and Niagara Falls, Church sought to invoke these sublime effects in the landscape he designed. At Manitoga, Wright too would incorporate the sublime tradition. Standing on the edge of the quarry cliff opposite the house, for example, visitors are both thrilled by the beauty of the composition and slightly unnerved by the sheer drop into the water. Neither Church nor Wright were trained landscape architects, but Olana and Manitoga share the connection of being "branded" by their creators, just as each signed his professional works.

Despite its links to historical precedents, Manitoga is indeed a modern landscape. Wright's selection of native plants reveals a contemporary ecological sensitivity, and rather than radically clear his land in broad swaths, Wright manipulated nature selectively so that Dragon Rock and Manitoga are in and of the landscape, not imposed upon it. Wright considered this illusion of a naturally occurring landscape a triumph. "Friends and neighbors consider it a fascinating and unusual piece of land," he recalled, "and I am amused and pleased to often be asked, 'How did you ever find such an unusually beautiful site?'—pleased because these friends think that I found it this way, and therefore I know that it looks natural."[7]

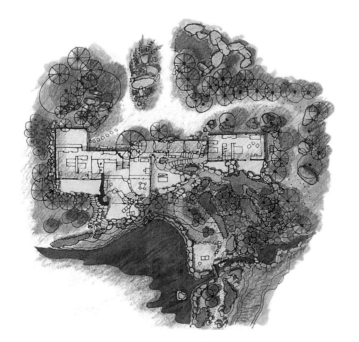

Site plan, Dragon Rock, 1982

Dragon Rock is composed of two volumes—one for family living (seen at the left in this drawing) and Wright's studio and bedroom (right)—connected by a loggia.

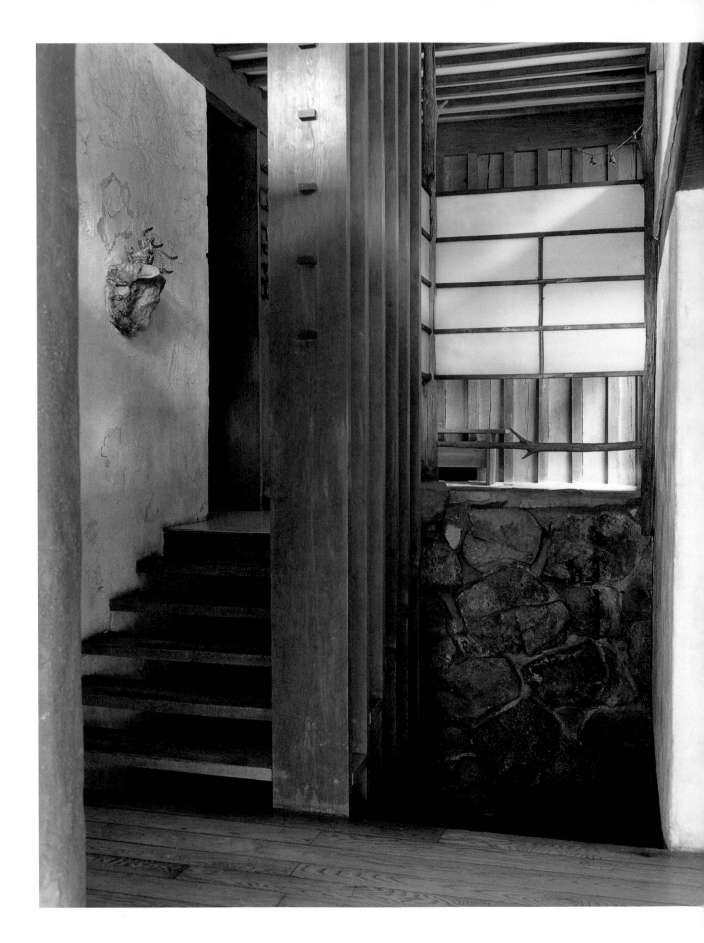

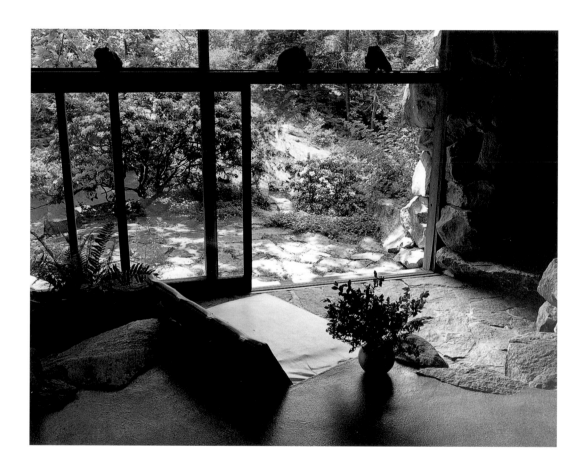

Entry hall (left) and living area (above), Dragon Rock, 1999

Wright's intent to merge his home with the landscape was achieved in part by using stone from the property for terrace paving and, inside, for floors and walls.

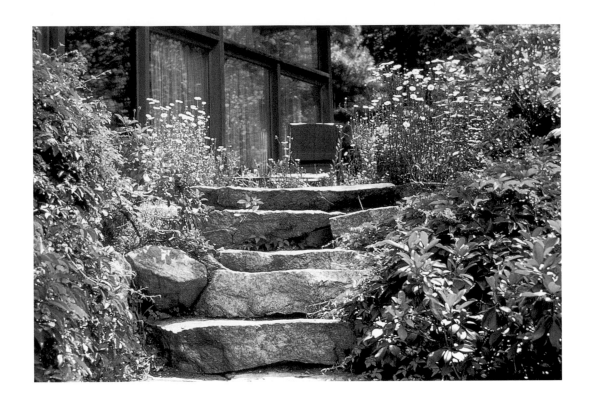

Terraces, Dragon Rock, 1970s (above) and 1999 (right)

Wright invoked the history of the property as both a quarry and a logging site by using stone and wood extensively.

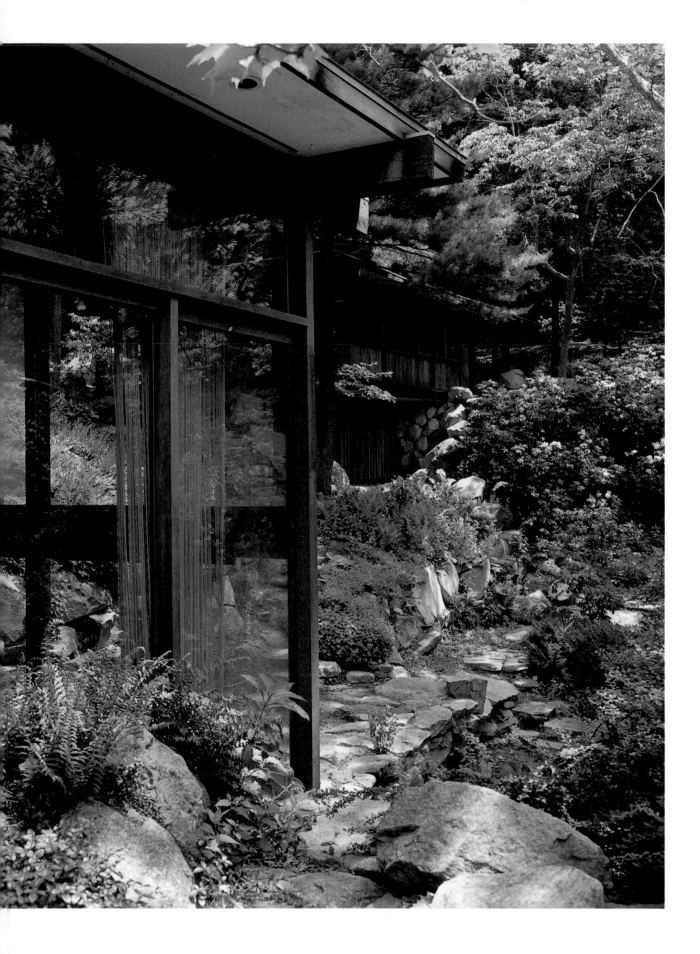

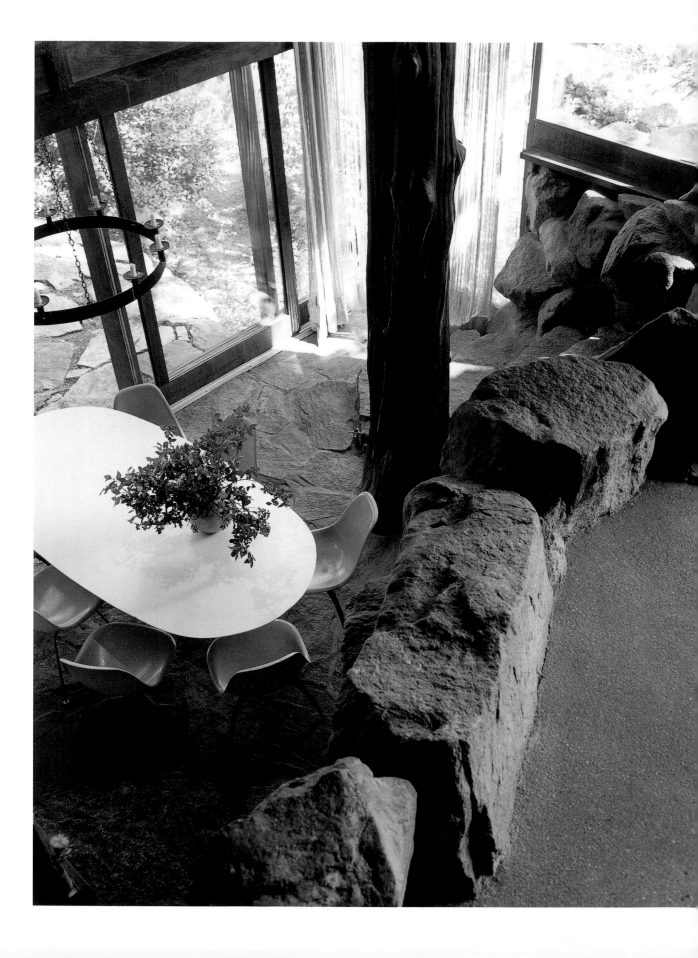

Left: **Dining area seen from living area, Dragon Rock, 1999**
Above: **Manitoga, 1970s**

Naturally occurring dramatic arrangements at Manitoga inspired Wright in defining
his living spaces. Boulders from the site rim the living space overlooking the dining
area. A massive tree trunk functions as a principal support for the house.

Manitoga, 1970s

Although natural in appearance, the waterfall that fills the large quarry pool, and the
stone paths farther from the house, were carefully designed by Wright.

Mary's Meadow (above), Martha Graham Girls (opposite, above), and woodland path
(opposite, below), 1970s

Mary's Meadow, the largest clearing on the property, was dedicated by Wright to his
wife. The Martha Graham Girls, named for their sway, are a group of birch trees care-
fully sited against a backdrop of dark green hemlock. Woodland paths are brightened
in the springtime by mountain laurel.

Following pages: **Manitoga, 1970s**

Wright's dramatic landscape design brought him full circle to his earliest practice of
stagecraft. At Manitoga he invited the audience onto the stage and into the play.

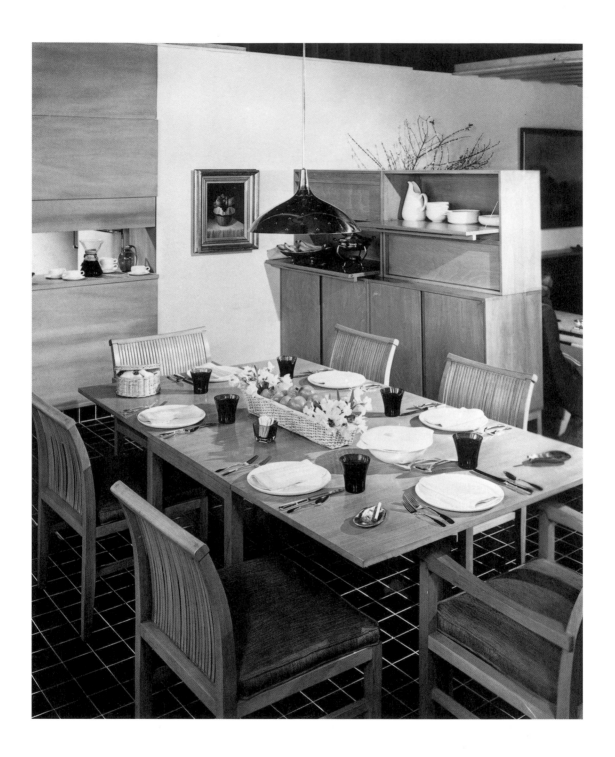

Demonstration room of the Easier Living furniture featured in McCall's magazine,
May 1951

MARKETING EASIER LIVING
the commodification of
Russel Wright

Robert Schonfeld

Despite Russel Wright's understanding that "an industrial designer must know as much about business...as possible," his considerable talents did not include commercial skills.[1] The historic successes and innovations achieved in marketing the Russel Wright brand are attributable primarily to the designer's wife, Mary Small Einstein, whose instincts and abilities in this area were equal to her husband's for design. The magnitude of these successes, in which the Wrights did not fully participate, having sold their interest, was largely the work of a manufacturing and sales organization founded by Irving Richards and Eugene Morganthau.

The facts notwithstanding, the public perceived Wright as a masterful business-man. At the height of his popularity, in 1949, an article in The New Yorker criticized Wright's work and mistakenly attributed to him a business savvy that he did not possess: "Mr. Wright's success may...have served to persuade designers and potters with more talent but less business acumen that the production of earthenware with a contemporary feeling would be a shrewd venture."[2] Mary Wright promptly responded, "Unfortunately, [the writer] is misinformed about Mr. Wright's 'business acumen.'... She should be delighted to hear that Mr. Wright many years ago gave up all manufac-turing and selling rights to his pottery.... To damn him with faint praise for business acumen he doesn't have is hard to take...especially when the profits are missing."[3]

If, indeed, profits were missing, Wright's success by measures other than money was remarkable. He was the first major industrial designer of the twentieth century to establish his own name as a national brand. His trademark signature, his image, and his ideas about living made him uniquely recognizable and authoritative as an arbiter of taste and lifestyle for millions of middle-class Americans. For homemakers in the

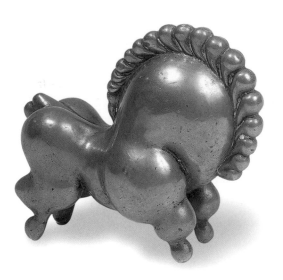

middle decades of the century, he was a trusted advisor. He made himself, in short, the American family's best friend.

With "evangelical" fervor, as Russel described it, he and Mary Wright pursued their goals through a variety of means.[4] Foremost was the consistent use of the name Russel Wright, and later, his signature, which was inscribed wherever possible on his products. Second was a comprehensive, multimedia promotional approach, which encompassed the products themselves, the way they were presented in stores (including exploitation of the relatively new techniques of open stock and starter sets), demonstrations that promoted the products' functionality, articles in newspapers and magazines, radio appearances, speeches, and books. The products themselves were inherently marketable, with features such as multiple applications, flexibility, ease of use, and durability—attributes that were irresistible to the American middle-class family. They were also introduced in coordinated lines that were especially attractive to both department stores and their customers. Although the Wrights did not invent these methods of marketing, they were innovative and relentless in the way they applied them, often as theme-oriented presentations and entire room settings, created with the purpose of helping consumers to visualize the products in use in their own homes. For he and Mary, Wright recalled, "converting the American public to simple contemporary design became a creative project."[5]

In 1929, when the couple was living in Rochester, New York, where Russel worked for director George Cukor on a demanding series of weekly theater productions, Mary defined the role that she would play in Russel's life for many years to come. She supported her husband's design work by doing virtually everything else herself. Among

her self-imposed chores were visits to retailers to persuade them to lend objects to the next week's production. This exposure to the world of merchandising would soon become invaluable as she promoted her husband's designs.

Their work in Rochester left the Wrights exhausted and nearly broke. In this state, they moved to New York City. Their main source of support was Mary's family, a fact that Mary carefully hid from her husband.[6] Then one day, as Mary recalled, "when we were feeling just a little more hopeless than usual," they were visited by Rena Rosenthal, the proprietor of a smart Madison Avenue gift shop.[7] In their apartment Rosenthal spotted sketches of large papier-mâché circus animals Russel had made for a theater in Woodstock. "Make some miniature editions of these in metal...and I will buy one hundred of each," she said.[8] Rosenthal's fashionable clientele, including Charles Lindbergh's wife, Anne Morrow Lindbergh, performer Libby Holman, and conductor Leopold Stokowski, was the perfect audience for an ambitious designer. Wright later remembered that Mary's teacher, Alexander Archipenko, praised his animals, and renowned sculptor and designer Isamu Noguchi said "they had the feeling of some Chinese sculpture."[9]

Even in this first commercial enterprise, the Wrights implemented one of their key marketing strategies: the promotion of Russel Wright's name. Each piece was stamped with Wright's initials, and a promotional brochure was entitled "Russel Wright's Circus." In addition, several pieces in this first line were functional as well as decorative. "Hotdog," a whimsical stainless steel dachshund, serves as a desk set; a scroll named "Calliope" acts as a bookend; and "Firedeer" is fashioned as an andiron.

The Wrights' growing awareness of the functional potential of modern design was encouraged by manufacturers they were just getting to know. With Edison Labs, an early collaborator, the Wrights produced a cocktail set, around 1930, in a choice of two finishes: pewter or silver-lined chrome plate. An ad for the line quoted *Vogue* magazine as proclaiming, "Russel Wright has designed a collection of cocktail paraphernalia that I consider quite epoch-making.... [It] combines the height of modernity with the height of practicality.... You wonder why no one thought of it before."[10] Silver lining and chrome plating, however, were too expensive for the Wright's broader target market, so they began to look for a material that was less costly and still adaptable to modern form and function. They also wanted a material that, like pewter, represented continuity with the tradition of American craft, to which the couple was committed.[11] They settled on spun aluminum.

Released in the early 1930s, Informal Serving Accessories was received by store buyers and consumers alike with great enthusiasm. With this success, the Wrights established their first company, Russel Wright, Inc. They began to turn out a wide variety of novel products, all conceived with the idea of simplified sociability, and every one stamped with the designer's name, even though, as Wright admitted, "Mary had

many of the ideas for the accessories."[12] Mary also conceived of theme-oriented presentations to market the new line, such as Sunday Supper and After-Skating Party, which she used in her promotional appearances in stores and on the radio, convincing consumers of the usability of these new products. Together, the Wrights handled every aspect of the business: Russel created the designs and supervised production, and Mary called on retail accounts and promoted her husband and his work with radio interviews, publicity in the print media, and in-store appearances. They even made deliveries themselves in their Chevy.

Soon, though, the enthusiastic reception of these early designs created the classic new-business problem of insufficient productive capacity to meet demand. This necessitated a move to larger quarters on East 35th Street, designed, of course, by Russel, and the hiring of a small staff, including design and sales associates. Shortly thereafter, in January 1933, Russel Wright, Inc., also retained an outside sales agent, Mary Ryan, an established wholesaler in the gift trade, where Wright's work

had its earliest acceptance, with the ability to reach markets outside the New York metropolitan area. Wright even redesigned Ryan's Fifth Avenue showroom at his own expense, and Ryan devoted considerable space to Wright's products.

Shortly after her hire, Ryan outlined a promotional plan for Wright's work, which showed how effective Russel and Mary's efforts to make his name central to their brand had already become. Ryan's plan began:

> This line has been brought to national prominence through continual publicity in style and house furnishings magazines and through newspaper syndicates: Russel Wright is the first to offer organized merchandise for informal serving.... Emphasize Russel Wright Design as you would if you were selling a "Chanel" dress.

Under "Publicity," Ryan wrote, "Russel Wright has become an important name!...Take advantage of the publicity value of this name by approaching your local newspapers, etc., with stories and photographs on Russel Wright merchandise for use on the Art Pages, Women's Pages, etc." In "Advertising," she advised, "Cash in on a name which

Mary Ryan showroom, Fifth Avenue, New York, 1933

carries with it national distinction…. Russel Wright is an American, 1933 craftsman. He works for the American market, for American tastes…. Russel Wright is a modern Paul Revere."[13] Connecting the modern designer to a traditional national icon reflected Wright's own purposeful Americanism.

Both trade and general interest publications readily picked up the story of Russel Wright. Nonetheless, Ryan's sales force did not produce either sales or publicity in quantities to satisfy Wright. The designer displayed unrealistic expectations for his agent's efforts and modest success. He wrote to Ryan, "Everything Russel Wright makes must sell."[14]

In 1934 the Heywood-Wakefield Company hired Wright to design a line of furniture in an Art Deco style, which Wright found constraining. Although unsuccessful in terms of sales, the effort had several positive outcomes for Wright. The display of the line at Bloomingdale's included rugs, lamps, fabrics, and accessories, all designed by Wright, thus furthering his self-proclaimed ambition to design "everything for the home."[15] These in-store room settings emphasized the flexibility of the line, from which pieces were available individually—a marked contrast to the customary practice at that time of selling furniture only in suites. This adaptability was carried through in some of the individual pieces themselves, notably a sectional sofa, believed to be another Wright innovation. The Heywood-Wakefield sales force also added items from Wright's Informal Serving Accessories line to their portfolio, increasing his sales and making Mary Ryan increasingly peripheral. The Ryan relationship was dissolved in August 1934, having lasted only twenty months.

Unhappy with the Heywood-Wakefield line but eager to design more furniture, Wright set out to create a line in solid maple, christened "blonde" by Mary in a new use of that term for home furnishings. Although some of Wright's designs for the Heywood-Wakefield line and the company's marketing approach were consistent with his and Mary's progressive view of the evolving American lifestyle, he could not reconcile himself with their limited stylistic range. Like many other manufacturers, Heywood-Wakefield was reacting to the powerful influence of the 1925 Exposition Internationale des Arts Décoratifs et Industriels Modernes in Paris, hoping to give their customers something modern.[16] But the sophisticated formal vocabulary, luxurious materials, and long tradition of highly skilled cabinetmakers in France did not translate into American manufacturing and distribution systems, which required much lower retail prices to reach the largest number of middle-class consumers, who were restricted by a Depression budget.

Heywood-Wakefield rejected Wright's proposal for the maple line, which Mary had titled "American Modern." Wright consulted Charles Shanessey, vice president for home furnishings at Macy's. Shanessey recommended Wright to Charles C. Brooks, Sr., president of Conant Ball, a traditional manufacturer in Gardner, Massachusetts,

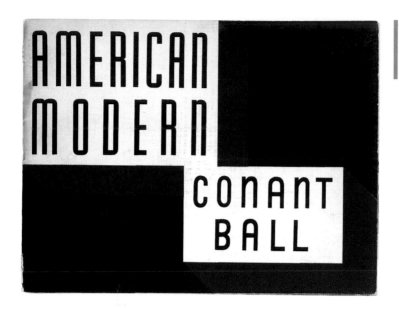

American Modern
furniture catalog,
ca. 1935

that had a solid reputation for reproducing "early American" furniture and whose full productive capacity was not being used. Mary's name for the line resonated with Brooks, who saw an opportunity to reinvigorate his company's tradition while at the same time acknowledging contemporary circumstances. Macy's promised a substantial initial order.

Conant Ball showcased the line at the 1935 furniture trade show in Grand Rapids, Michigan, and displayed it in room settings, again designed by Wright. Their catalogue for the line began, " 'American Modern' is the present-day continuation of Colonial American furniture. Built in maple, the wood of our forefathers, it is designed to express in the twentieth century manner, the simplicity and frank construction of American Colonial furniture. Just as Early American related to early American times, so does 'American Modern' relate to our modern American scene."[17] Macy's went much further, installing an entire Modern Maple House in the furniture display space on their ninth floor in the summer of 1935. Macy's catalogue enthused, "Russel Wright designed it. The town's ecstatic about it."[18] A newspaper ad placed by the store proclaimed, "It's not quaint Colonial. It's not dizzy modern. It's not expensive. It's only at Macy's in New York."[19] The store's delight with their commitment to Wright was expressed in a statement issued by O. L. Overby, Macy's furniture buyer:

Turned down by one of the largest producers of maple furniture in the country and close to Spring market time, Russel Wright came to us with the first designs for solid maple furniture. Conant Ball, New England furniture manufacturers, were found. Our prophecies that these designs of Mr. Wright's were the most important development in American furniture in the last few decades has been fulfilled to the

American Modern desk (far right) in Macy's advertisement, *New York World Telegraph*, August 6, 1935

tune of $250,000—Conant Ball's retail sales per year—not to mention the sales of all like designs immediately following suit. The idea has now become a species![20]

The deft positioning of the Conant Ball line as an American product that was contemporary but also connected to tradition represents an important aspect of Mary's merchandising strategy. The delicate and difficult task of differentiating her husband's work from the competition is articulated by her in "What Is Swedish Modern?," an undated short essay probably written about 1933 but never published. In it, Mary coined "American Modern," the name that was applied to the core product lines in her husband's career.

Let us consider the cases of the glamorous Garbo and our own Jean Harlow. Garbo had the glamour, Harlow the box office appeal—yet few of the people who made up Harlow's intrigued public, including the actress herself, ever realized that a large portion of Harlow's equipment was borrowed consciously or unconsciously from the Swede. The very wave of her hair, the exaggerated mouth, eyebrows and lashes, even certain elements of her histrionic personality were influenced by Garbo. What Garbo started our American actresses have exploited—but figures prove that the American adaptation is what's wanted.

In the same way, it is quite probable that the qualities of the Swedish Modern which are so well liked today will soon be incorporated by the American designers into their own modern furniture, lamps, and accessories, and will be liked and wanted by the American public long after the term "Swedish Modern" is forgotten. For Americans, with their gift of absorbing and exploiting the best of what other countries have to offer in terms of their own requirements, will not be long in fusing this style with their own. When that time comes, and it is not unlikely that it is more than a year off, alert manufacturers should be ready to shift the emphasis from the foreign inspiration to the domestic realization. Then they will emphasize with equal stress and with probably equal success, the new style of "American Modern."[21]

Lacking formal training, but with her family's merchant genes and her own direct experience with retailers, Mary understood the importance of simultaneously making her husband's work stand out from the competition and placing it in a framework that was easy for the consumer to remember and identify with: American and modern. Further, Mary cleverly directed her husband toward work that, in its modernity, was new and different in ways that made it an extension of retailers' product lines, rather than a competitor with them, so that it was not a threat to the existing business of either manufacturers or their retailers. Mary correctly read the social and economic circumstances of the time and matched her husband's strengths to them in a way that created significant business opportunities. Russel Wright believed that his success with his Informal Serving Accessories and American Modern furniture had "made modern design understandable to the homemaker."[22] With the help of his wife, the trade press, and retail advertisers, he had also succeeded in making his own name synonymous with modern design at modest prices.

Wright's next project under the American Modern rubric, a line of dinnerware, was conceived by Russel and Mary as a logical extension of their persistent effort to identify their work with the spirit of their country and the times. The American Modern brand, which consumers already recognized from the furniture line, would be used for dishes, as well as glassware and linens that complemented the dinnerware. This ingenious marketing technique gave sales representatives the advantage of a powerful cohesiveness that was especially appealing to buyers for department stores.

Store advertising contributed heavily to the deepening connection between Wright's name and products that balanced modern design with American tradition. One advertisement promoted "Enduring American Originals...Edison's phonograph and American Modern." Another ad in the same campaign was even more fundamental: "Two beloved traditions, born to give pleasure to every taste—the Thanksgiving turkey [and] American Modern dinnerware!" Advertising for American Modern dinnerware

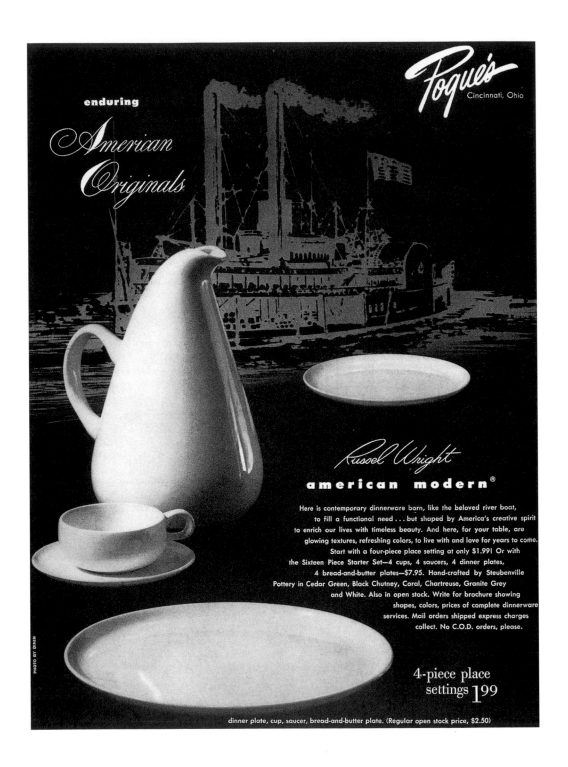

Advertisement for American Modern at Pogue's, Cincinnati, House and Garden, July 1952

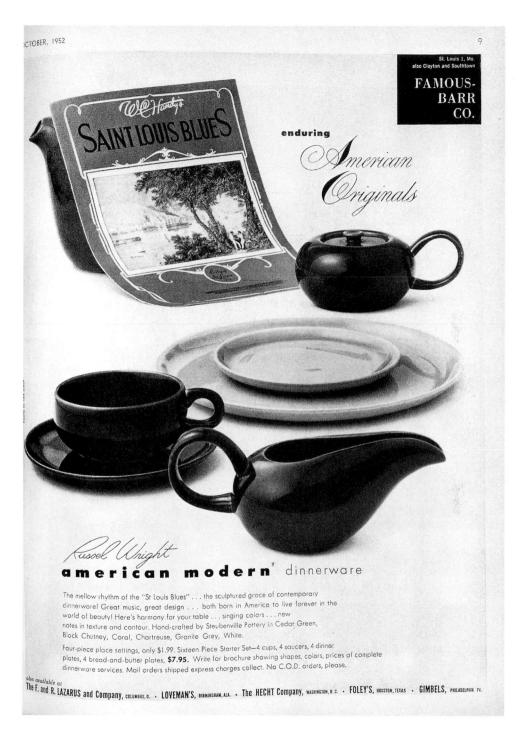

enduring

*American
Originals*

Russel Wright
american modern dinnerware

The mellow rhythm of the "St Louis Blues" . . . the sculptured grace of contemporary
dinnerware! Great music, great design . . . both born in America to live forever in the
world of beauty! Here's harmony for your table . . . singing colors . . . new
notes in texture and contour. Hand-crafted by Steubenville Pottery in Cedar Green,
Black Chutney, Coral, Chartreuse, Granite Grey, White.

Four-piece place settings, only $1.99. Sixteen Piece Starter Set—4 cups, 4 saucers, 4 dinner
plates, 4 bread-and-butter plates, **$7.95.** Write for brochure showing shapes, colors, prices of complete
dinnerware services. Mail orders shipped express charges collect. No C.O.D. orders, please.

also available at
The F. and R. LAZARUS and Company, COLUMBUS, O. • LOVEMAN'S, BIRMINGHAM, ALA. • The HECHT Company, WASHINGTON, D.C. • FOLEY'S, HOUSTON, TEXAS • GIMBELS, PHILADELPHIA PA.

Advertisement for American Modern at Famous Barr Co., St. Louis, *House and Garden,*
October 1952

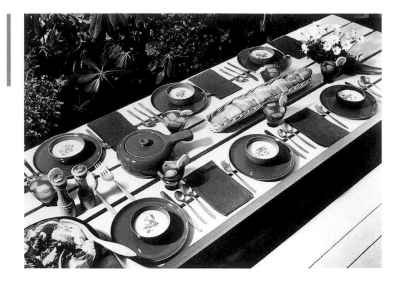

introduced yet another marketing innovation: the designer's distinctive, loopy signature in place of his printed name. From this time forward, its presence would be a requirement in all advertising and promotion of Russel Wright products, as would the contractual stipulation that the signature be at least as large as the largest type on the page. His signature also dominated the backstamp on the pottery.

The designs for American Modern dinnerware were developed over a period of years, beginning about 1935. By this time, the sales of Russel Wright, Inc., were more than $100,000. With the salaries they drew, the business's profit, and royalties from Conant Ball and other clients, the Wrights were succeeding well beyond their expectations. At the same time, they were confronted, once again, with commensurate business problems. Russel's time was absorbed almost entirely with design, as was Mary's with promotion. This left administration, production, and sales in need of professional help. As they had in the past, the Wrights turned to their contacts in the trade for ideas. One of these contacts was Andy Rouge, an experienced gift and housewares buyer for Ovington's, a specialty shop on Fifth Avenue in New York City that had been successfully carrying Wright's work for years. Rouge suggested that the Wrights meet a young salesman named Irving Rappaport (later Irving Richards), the son of a successful coat and suit manufacturer and real estate developer.

The Wrights hired Rappaport in 1936 for $100 per week, but Rappaport boldly asked to buy half the business. Wright agreed to sell him 20 percent of his business for $5,000 and to sell him a further 30 percent interest by June 30, 1939, making him an equal partner.[23] No explanation for Wright's decision is found from contemporary sources or archival material, except that the designer often expressed a distaste for business and a desire to be free of it. The Russel Wright, Inc., financial statement for

1936 shows nearly $40,000 in net assets and a year-end surplus of more than $43,000. Sales for the year were $101,637.28, with a respectable gross margin of $52,275.95, or more than 50 percent. After all expenses, including commissions and their own salaries, the business yielded a net profit from operations of $2,139.59.[24] Wright's only comment justifying his decision is that his "various business responsibilities had become too much."[25] Ironically, he was intensively involved in the business aspects of his work before, during, and after this period. Roughly nine months later, after separating himself formally from the company he had founded with his wife, Russel Wright was left with a retainer of $4,000 per year for four years, against which he was to be paid a royalty of 4.5 percent for items manufactured by the company and 3.5 percent for items manufactured outside. Soon included in the latter category was a line of dinnerware believed to be the most successful, and in many ways the most extraordinary, ever created—American Modern, the designs for which were well under way by this time.

To produce American Modern pottery, Rappaport attracted a manufacturer with the same method the Wrights used for the furniture line—finding an established company whose business had fallen off. Through Dave Ballantine, a buyer for the J. L. Hudson department stores in Detroit, Rappaport found Henry Wintringer, owner of the nearly defunct Steubenville Pottery in Ohio.[26] Wintringer, like Charles Brooks at Conant Ball, recognized an opportunity to revive his flagging business. He agreed to produce the pottery as long as Wright and Rappaport paid for the molds. The line was introduced at the New York and Chicago gift trade shows early in 1939, but because of difficulties in producing the unusually shaped pieces and perfecting the glazes, the first deliveries didn't arrive at stores until the fall of that year. Buyers were wary.

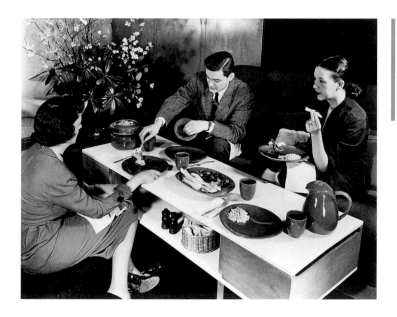

Promotional photograph of table setting with American Modern dishes on Easier Living coffee table, mid-1950s

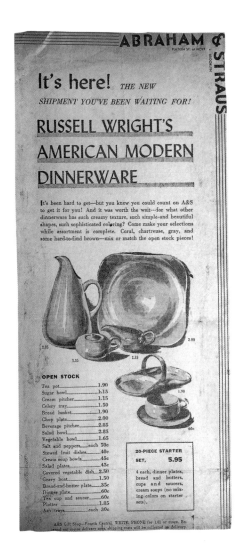

Advertisement for
American Modern
dinnerware at Abraham
& Straus, New York,
ca. 1940

Macy's and a few other outlets placed small orders. Editorial coverage and advertising, meanwhile, did not take off until the spring and summer of 1940. Initial sales were slow. Nervous, the Wright-Rappaport team took promotion into their own hands. They paid for newspaper advertising themselves. Some of the ads emphasized rich colors, beautiful shapes, creamy texture, and, in the case of B. Altman's in New York, "jewel-like transparent glazes." Altman's also encouraged customers to "see our special table settings showing how interesting this ware is for every occasion."[27] Consistent with their long-standing practice, the Wrights created themed table settings and much store display material. Mary visited radio stations and made in-store appearances. Mindful of her audience, namely the woman who bought almost all her family's housewares, Mary shrewdly presented herself not as the brilliant marketer and business partner she was, but as a housewife who had benefited from her husband's products. As early as a

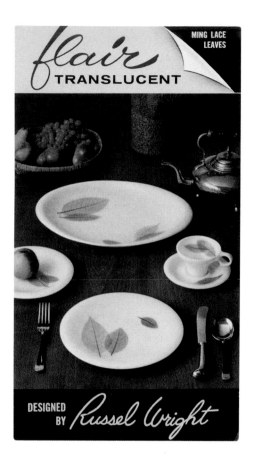

1933 store appearance she had said, "I am here not so much as myself, but as a lesser half—a wife. I am here to tell you something about Russel Wright, my husband, and the part he plays in the housewife's life today."[28]

To encourage sales of American Modern, "starter sets" of various sizes were offered at a discount from open-stock prices. Twenty pieces were offered for $5.00 to $5.95; the same pieces bought as open stock cost $8.00. Wright and Rappaport offered stores a liberal returns policy for unsold merchandise. Before long, the consuming public had been beguiled by the seductive shapes and colors of this new pottery. Enticed by the aggressive Wright-Rappaport promotional schemes, customers were encouraged to mix, match, and arrange their tables to suit an endless variety of informal social situations. Soon, demand was outpacing supply. When Steubenville had trouble keeping up and orders were delayed, stores turned the situation to their advantage. New York department store Abraham & Straus proudly announced, "It's here! The new shipment you've been waiting for…. It's been hard to get—but you knew you could count on A&S to get it for you!"[29] For years to come, demand for American Modern dinnerware would far outstrip supply, sometimes causing a fracas among anxious customers.

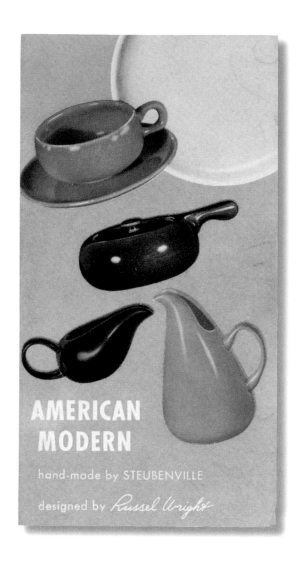

AMERICAN
MODERN

hand-made by STEUBENVILLE

designed by *Russel Wright*

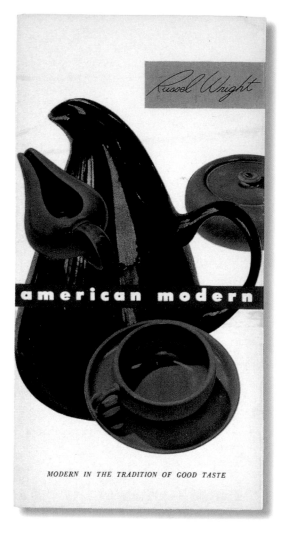

Russel Wright

american modern

MODERN IN THE TRADITION OF GOOD TASTE

Brochures for American Modern and Iroquois Casual China, 1930s and 1940s

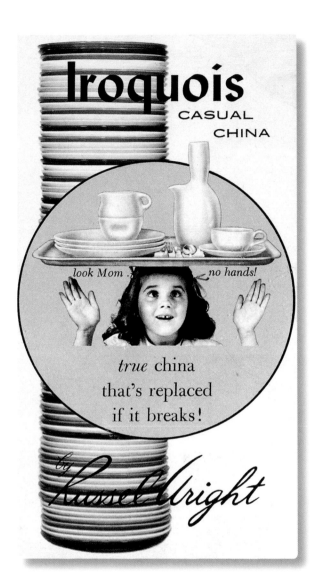

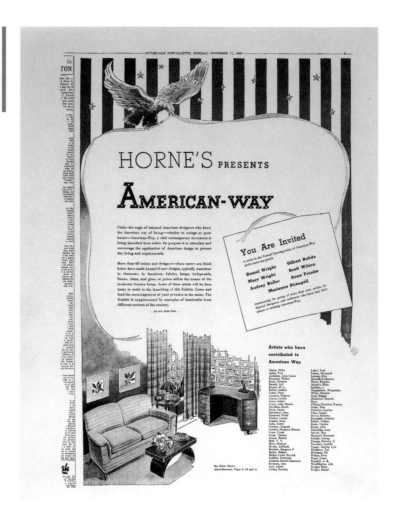

As their signature product was about to take off, around 1939, Russel and Mary
Wright embarked on a cross-country driving trip with the idea of immersing them-
selves in the American scene in order to better serve their market. On this trip, Russel
further developed his "love and allegiance to America."[30] Giving shape to his strong
feelings, he conceived a massive project that would bring together more than seventy
designers and craftspeople, and dozens of manufacturers to produce a group of
designs to be offered to consumers through retail stores as a coordinated program.
This, Wright believed, "will be more powerful, more efficient, more attention-command-
ing than scattered individual product single 'line' presentations."[31] The Wrights took
their earliest and most consistently successful technique—theme-oriented presenta-
tions—and extended it into a merchandising concept reaching into every corner
of their trade. They also responded to timely concerns, according to a press release:
"Behind America's growing tendencies toward self-reliance in every field, is the war

with its critical curtailment of European sources, both manufacturing and creative, prompting the recognition of our own resources…. National pride has permeated the country."[32] They called their project American Way. "American Way," the *Magazine of Art* announced, "is merely acting upon and bringing up to date ideas which have been current in American communities since this nation was founded. With intelligent direction, a strictly commercial venture of this sort is apt to benefit the craftsman more than all the efforts of sentimentalists who have supported his work primarily as a reminder of a vanishing era."[33] A full cross-section of America was represented; the project was marketed as "a middle way between the ultra-sophisticated and the truly rural."[34]

In the midst of the elaborate preparations for this project, Russel expressed to Mary his feeling that their "various business responsibilities [had become] too much."[35] This sentiment is especially peculiar because, by 1937, Wright had exempted himself from virtually all responsibility except for design, which was

Mary and Russel demonstrating the durability of Iroquois Casual China, late 1940s

upholstered
with an
exclusive

Russel Wright

design

in cleanable Du Pont

Fabrilite®

. fabric supported
vinyl · plastic upholstery

Counter card for
Fabrilite upholstery,
mid-1950s

Fabrilite was part of a
series of vinyl fabrics
Wright designed for
DuPont for use in
homes, automobiles,
and industry.

provided under a retainer to a new entity, Wright Accessories, Inc., formed in 1937. The shareholders of the new company were Mary Wright, Irving Rappaport, Eugene Morganthau, and the Wrights' early associate, Hans Forcheimer.

Wright quickly realized that Mary's assistance would be indispensable to getting the mammoth American Way project off the ground. Disregarding the fact that Mary's shareholding in Wright Accessories, Inc., was their last tie to the company they had founded, he began to argue strongly for her withdrawal from the company, where she seems to have been perfectly positioned not only for her own interests, but for her husband's as well. After bitter disagreements, Mary finally acceded. On December 7, 1940, she and Hans Forcheimer sold their interests in Wright Accessories, Inc., to Irving Rappaport's brother Harold for $13,000 (or $100 per share, the same valuation upon which Wright had sold his own shares in 1937).[36] The resulting firm changed its name to Raymor, which was actually two firms, one an importer and distributor, the other a sales agency. (It was at about this time that both Irving and Harold Rappaport changed

Counter card for Eclipse glassware, ca. 1957

Eclipse was one pattern of glassware designed by Wright for Bartlett-Collins that was marketed to the low end of the consumer market.

their last name to Richards.) In this deal, which Mary vehemently opposed, the Rappaport brothers acquired all present and future earnings from American Modern dinnerware, with the exception of the 3.5 percent royalty due to Russel.[37]

Russel and Mary Wright focused on American Way, but the tremendously complicated project was a near-total failure. Even Mary's superb organizational and promotional skills and a grand launch at Macy's by First Lady Eleanor Roosevelt could not hold together Russel's quixotic but well-meaning concept. Maintaining uniformity and timely deliveries with so many craft-based products proved impossible. The strategy of showing certain portions of the line at different stores at different times, as well as restocking with new merchandise from so many individual sources, was impractical. The Wrights were managing more than 140 contracts with various designers and companies.[38] Fewer than twenty stores nationwide were able to offer the complete American Way program at the outset in 1940. Reaching far beyond their managerial and financial means, the Wrights took on a role that today would be filled by merchandise managers for several divisions of a large department store. It was just too much.

The Wrights lost their entire investment of $60,000, "almost all we had," according to Russel. To repay outside investors, Russel signed over his remaining royalties from American Modern dinnerware, which was still selling strongly. To make matters worse, work contracted for the Chase Brass and Chrome Company was curtailed due to wartime material shortages, and a planned line of knockdown furniture for Sears Roebuck was never launched. Although not required to do so, Wright returned the advances the companies had paid him. Wright recognized later that this was "stupid and indicates a lack of business sense and perhaps a masochistic tendency." He

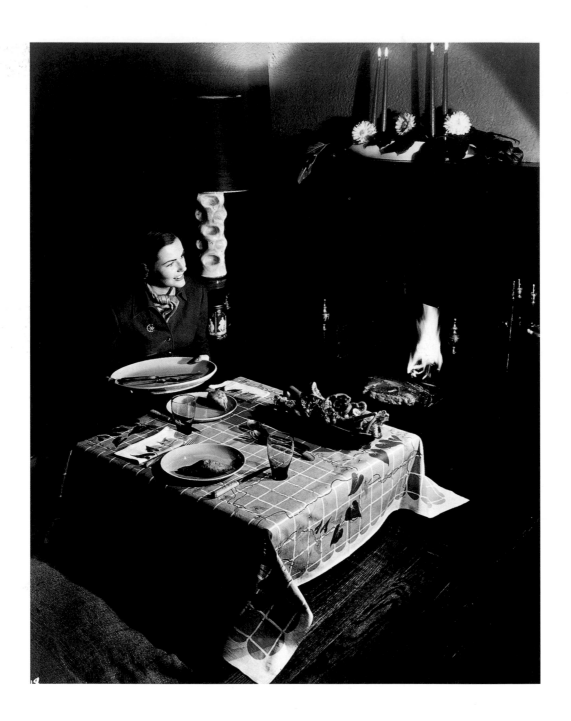

Promotional photograph, Picnic in the Living Room, for Leacock Linens, ca. 1948

In a themed presentation typical of the Wrights' marketing campaigns, a young woman has used Russel Wright furnishings—including dinnerware, glasses, and Silver Lace linens—to create an indoor picnic for her date.

described these years as the worst of his life. Most especially, in the "great mix of discouragement and failure" permeating his life, Wright recognized that he had precipitated a "sudden change of life with Mary due to our disagreement over the sale of our business." The "loss of income made Mary very unhappy and was the reason for our married life becoming a very unhappy one." Only after her death from breast cancer in 1952 did Wright acknowledge the pain and hardship he had caused the woman who had, for all intents and purposes, turned her life over to him. "In retrospect," he allowed, "Mary was right."[39]

After the war, Wright returned to the kind of smaller-scale work he had mastered. In 1946 he launched a new line of dinnerware, named Casual China by Mary and manufactured by the Iroquois China Company of Syracuse, New York. Once again, functionality was an important design element. Made of high-fired vitreous china, the pieces were suitable for use in the oven, on the stovetop, or at the table, and unlike the fragile American Modern pottery, they were extremely resistant to chipping or breaking. Russel and Mary's in-store promotions highlighted these attributes: after washing a sinkful of the dishes, they would dump them from a drainer onto a metal tabletop. Often only one dish—or none—would break.[40]

Iroquois Casual China was heavily promoted as the first true china for everyday use. Press materials emphasized that "you can cook, bake, broil, roast...then serve in this remarkable guaranteed china that eliminates pots-and-pans drudgery forever.... Safe even in the hands of the littlest children and, of course, neither dishwashers nor detergents can harm it."[41] Such features were important in newly affluent postwar households across the country. And, needless to say, every ad carried Wright's signature, sometimes twice.

Wright was concerned in the postwar years that the disproportionate success of his dinnerware designs had pigeonholed him in the minds of consumers. Over the next ten years he produced a significant and diverse body of work for a variety of clients, including glassware for the Imperial Glass Company, the Old Morgantown Glassware Guild, and Bartlett-Collins; table coverings for Simtex and Leacock, among others; Residential plastic dinnerware for the Northern Industrial Chemical Company, which arose from seminal product development he conducted for the General American Transportation Company and American Cyanamid; folding furniture for Samsonite; vinyl fabrics for DuPont; and Highlight/Pinch flatware for John Hull Cutlers. All of these products bore his signature.

Moreover, Wright longed to further develop his and Mary's concept of the home as an integrated, organized, functional environment. The press materials for the American Way articulate this vision: "Today, in the face of an increasingly complicated and speeded up existence, the necessity to provide a well-planned home background is more urgent than ever before.... A well-planned home can provide the basic ease

Advertisement for *Guide to Easier Living*, November 13, 1955

Even five years after its initial publication, *Guide* was still being promoted.

which results in gracious living."[42] In 1950 he and Mary published a manifesto for their philosophy, *Guide to Easier Living*.

The physical expression of "easier living" was a coordinated group of home furnishings, the centerpiece of which was a large line of furniture for the Statton Furniture Manufacturing Company, introduced to the trade at the Grand Rapids industry show in January 1951. In what was by this time signature fashion, the Easier Living furniture was shown in room settings designed entirely by Wright. Demonstration rooms were also created for *McCall's* magazine a few months later. The furniture line offered a tremendous array of ingenious features and newly developed materials, all of which were promoted for ease of use and multiplicity of function. There were innumerable hidden compartments, drop leaves, extensions, and pullouts. Fabric covers snapped on and off. Wright helped develop a high-fired vitreous porcelain called Plyporcel, which was virtually impermeable to flame, liquids, or heavy use. The quintessential piece in the line was a chair on which one arm swung up to provide a tray or writing surface, and the other swung out to serve as a

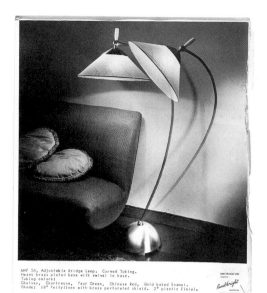

MAF 56, Adjustable Bridge Lamp. Curved Tubing.
Heavy brass plated base with swivel in base.
Tubing colors:
Chutney, Chartreuse, Pear Green, Chinese Red, Gold baked Enamel.
Shade: 10" Pollylinen with brass perforated shield. 3" plastic finial.

No. 5050
35×15
Height Closed 15 Height Open 18

No. 5016
Overall Width 47½ Inside Width 25
Overall Width Closed 29½
Overall Depth 39 Height 33

storage area. *Retailing Daily* reported, "Not stopping with furniture, Mr. Wright has come up with a group of coordinated rugs, upholstery and drapery fabrics, and lamps, all of which will be shown with the furniture."[43]

Early in his career, Wright had noted that he was "anxious for sales for [their] influence and conversion [of consumers], not money."[44] In pursuing this goal for more more than twenty years, he came to dominate the home furnishings market as no one had before him. A 1951 poll conducted by *Living for Young Homemakers* magazine found that Russel Wright's popularity was unparalleled. In response to the question, "What brand of dinnerware do you have (your best set)?," Wright and Haviland, a manufacturing company, were the most common answers, with 9.6 percent each, followed by Lenox with 7.2 percent. Although so many participants already owned Wright dishes as their best set, when they were asked which brand they planned to buy for another set, Wright received 9.1 percent of the responses, second only to Lenox, which received 11.9 percent. More than 120 brands were listed in response to the first question, and more than 50 in the second, and all but Wright were manufacturing companies. No other individual designer even made the list.[45]

Catalog photograph for Easier Living lamp, ca. 1951

Catalog photograph for Easier Living Reading and Writing chair, ca. 1951

Russel Wright had succeeded in his ambition to design "everything for the home," as well as the home environment itself. The shy boy from Ohio had achieved the critical mass of stardom. His persona was a source of comfort and confidence for millions of families establishing themselves in the prosperity and security of the postwar years. He was by any measure the most successful practitioner in his chosen field.

After Mary's death in 1952, Wright continued to design for another sixteen years for the American family at home, but he increasingly retreated from the commercial sector. His iconic status in the design profession as well as his unprecedented name recognition with the public led to numerous requests for his participation in a growing public dialogue about design. Among other things, he served as president of his professional group, the Society of Industrial Designers, and represented the United States on a 1955 trip to Southeast Asia meant to assist countries of the region in developing their handcraft industries. But eventually, the man who, more than any other in the mid-twentieth century, was associated with lifestyle merchandising withdrew to his eighty-acre property in the Hudson River Valley. His work remains highly popular and sought after today in the secondary market, giving it a timeless quality and extending his brand name without interruption into another century.

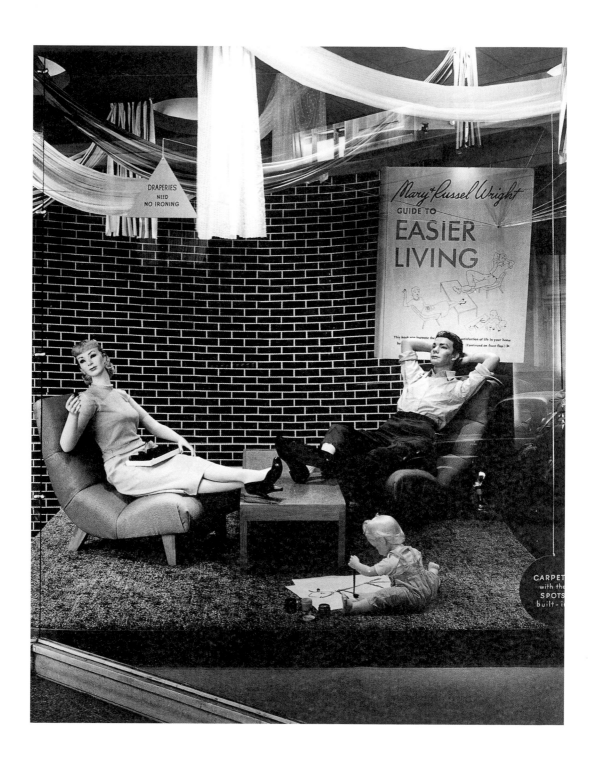

Modernage store window display of Easier Living furniture, 16 East 34th Street,
New York, ca. 1951

NOTES

Russel Wright's archive in the Department of Special Collections at Syracuse University Library (hereinafter Wright Archive) contains drawings, correspondence, three-dimensional objects, photographs, and promotional material, providing a complete and detailed overview of the designer's life and career. Throughout the following notes, references to documents from the archive consistently omit box and folder numbers. Since research began on this project, many years ago, the archive has been recatalogued and reorganized, resulting in revised box and folder numbers. A conversion to current box and folder numbers is not possible, but the library has created an excellent finder's guide.

INTRODUCTION

1. Wright was born Russell, but years later, when letterhead was delivered with only one ell, Wright decided to live with the change as it was distinctive. This story is recounted by Russell Lynes in the Foreword to William J. Hennessey, Russel Wright: American Designer (Cambridge, Mass.: MIT Press, 1982).

2. Ann and Russel were also interviewed by Edward R. Murrow for his television show in the late 1950s.

3. Quoted in Rita Reif, "Russel Wright, Pioneer Designer in the Modern Mode, is Dead at 72," New York Times, December 23, 1976.

4. Wright's mother, Harryet Morris Crigler, was the daughter of Aaron Crigler and Elizabeth Longworth Morris, a direct descendant of Robert Morris and William Whipple, who signed the Declaration of Independence.

This information is drawn from an unpublished biography of Russel Wright (hereinafter known as Wright Biography) currently in possession of his daughter, Ann Wright. The manuscript was written in different phases throughout the 1950s.

5. Wright Biography, 5.

6. These comments come from a series of taped interviews (hereinafter known as Wright Tapes), conducted near the end of Wright's life by Marley Beers, now in the possession of Ann Wright.

7. Ibid.

8. Archipenko established a summer program in Woodstock in 1924.

9. Wright Biography, 19 and 21.

10. Marketing material for American Way, n.d., n.p, Wright Archive.

11. Russel and Mary Wright, Guide to Easier Living (New York: Simon and Schuster, 1950), 2.

12. Ibid., 4.

13. Russel Wright, "A Garden of Woodland Paths" (written 1970; published Garrison, N.Y.: Manitoga, 1999), 2.

14. Interview with Ann Wright, by Donald Albrecht, November 2000.

15. Wright, "A Garden of Woodland Paths," 1.

16. Richard Hofstadter, in his book The American Political Tradition and the Men Who Made It (1948), discusses the ways that American political reformers, from Thomas Jefferson to Theodore Roosevelt and Woodrow Wilson, have turned contradictory traits to their advantage. To the list of progressive reformers, we would add Russel and Mary Wright as well as Frank Lloyd Wright.

A MAN AND HIS MANNERS

1. Russel and Mary Wright, Guide to Easier Living (New York: Simon and Schuster, 1950).

2. Mary Ryan, "Memorandum on the Russel Wright Line," n.d., Wright Archive.

3. Russel and Mary Wright, Guide, 28.

4. Elaine N. McIntosh, American Food Habits in Historical Perspective (Westport, Conn.: Praeger Publishers, 1995), 106.

5. Glenn Beyer, ed., The Cornell Kitchen: Product Design through Research (Ithaca, N.Y.: Cornell University, 1952), 9.

6. Russel and Mary Wright, Guide, 125. Engineering the home to maximize efficiency has its own tradition in the United States. In The American Woman's Home, Catharine Beecher advised arranging sink, stove, and cupboards to create convenient work surfaces and to minimize wasted motions.

7. Sylvia Lovegren, Fashionable Food: Seven Decades of Food Fads (New York: Macmillan, 1995), 41.

8. While the former items sold very well, the latter were largely unsuccessful, according to a letter from Mary Ryan to Russel Wright, of August 17, 1934 (Wright Archive).

9. Mary Ryan, "Memorandum on the Russel Wright Line."

10. Penny Sparke, "Cookware to Cocktail Shakers: The Domestication of Aluminum in the United States, 1900–1939" in Sarah Nichols, ed., Aluminum by Design (Pittsburgh: Carnegie Museum of Art, 2000), 226.

11. Mary Ryan, "Memorandum on the Russel Wright Line."

12. Press materials for the Leacock Linens line, ca. 1946–48, Box 20, Wright Archive.

13. Herbert Read, Arp (London: Thames and Hudson, 1968), 88.

14. David Hanks with Jennifer Toher, Donald Deskey: Decorative Designs and Interiors (New York: Dutton, 1987), 50–53.

15. Conant Ball sales tips, n.d., 1, Wright Archive.

16. Ibid., 6.

17. "Conant Ball Co. Introduces 'American Modern,' Designed by Russel Wright," marketing brochure, 1935, 1, Wright Archive.

18. O. L. Overby, "Statement," n.d., Wright Archive.

19. Ann Kerr, The Collector's Encyclopedia of Russel Wright Designs (Paducah, Ky.: Collector Books, 1990), 74–75.

20. Read, Arp, 42.

21. Charles L. Venable et al., *China and Glass in America, 1880–1980: From Tabletop to TV Tray* (Dallas: Dallas Museum of Art, 2000), 430.

22. Russel Wright, "Change the Scene with Accessories," *Living for Young Homemakers* (February 1954).

23. Manny Faber, "Like a Rock Cast in the Sea," *New Republic* (November 20, 1944), 661–62.

24. Brett Harvey, *The Fifties: A Women's Oral History* (New York: HarperCollins, 1993), 110.

25. Seibel's lines were called Impromptu and Informal True China. By contrast, Iroquois's formal name for Casual China was "Russel Wright Casual China," suggesting the marketability of Wright's name. (Iroquois China Company press release, n.d., Wright Archive.)

26. In the mid-1950s, at Iroquois's suggestion, Wright added several floral decals to the line, which were intended to revive flagging sales and meet the new demand for floral dinnerware. These versions were not popular.

27. Correspondence between Wright and various employees of Iroquois China Company document the end of the line. Wright Archive.

28. "Museum of Modern Art Shows New China in Modern Design," undated press release, and "Explanation of the 1946 MOMA Exhibition of Fine China," undated designer's statement by Eva Zeisel, Museum of Modern Art, Architecture and Design Study Center files.

29. Venable et al., *China and Glass in America*, 385.

30. Martin Eidelberg, *Eva Zeisel: Designer for Industry* (Montréal: Musée des Arts Décoratifs de Montréal, 1984), 36.

31. Ibid., 465.

32. Russel and Mary Wright, Guide, 125.

33. Ibid., 166–67.

34. Ibid., 165.

35. Ibid., 172.

36. Ibid., 176.

37. "Building a Dream House—The Story of Dragon Rock," n.d., 16, Wright Archive.

38. Statton Furniture Manufacturing Company, "What Is Easier Living" sales brochure, ca. 1950, 2, Wright Archive.

39. Venable et al., *China and Glass in America*, 150–55.

40. Ibid.

41. Ibid., 434.

42. Kerr, *Collector's Encyclopedia*, 131.

43. Ibid., 113.

FROM HOLLYWOOD TO WALDEN POND

1. Among the productions he participated in were *Marco Millions*, designed by Lee Simonson, and Eugene O'Neill's *Strange Interlude*.

2. This term was used by *Esquire* magazine to describe Wright's yacht club, "designed for the modern yachtsmen of our democratic day" in "For Yachting on a Modest Scale…Designed by Russel Wright," *Esquire* (August 1939), 89.

3. Wright Biography, 18. Wright often talked about his work in terms of establishing a mood, and the appearance of the word *mood* in this quote suggests that it expresses Wright's own opinion.

4. Russel Wright, "Garrison Slide Lecture," typescript, April 1961, Wright Archive. Wright was discussing his own home, Dragon Rock.

5. Wright Biography, 18.

6. The 35th Street apartment was the first Russel designed for himself and Mary. Previously they lived at 18 Beekman Place on Manhattan's East Side.

7. Wright Biography, 23–24.

8. It is not known why this movie was made. The Wrights' daughter, Ann, believes it was for their own amusement. Interview with author, November 2000.

9. "Repeal Remodeling," *Architectural Forum* (March 1934), 187.

10. The Durelle Tea Room was located at 400 Madison Avenue.

11. "Modern Backgrounds for Modern Merchandise," n.p., n.d., press statement in the possession of Ann Wright. The word *architectural* in the quoted passage has been written in by hand.

12. "Designer at Home," *House Beautiful* (April 1934), 31.

13. William J. Hennessey, *Russel Wright: American Designer* (Cambridge, Mass.: MIT Press, 1982), 79.

14. A celebrated example of plastic laminates in Depression-era interior design is Donald Deskey's furniture in the public rooms of Radio City Music Hall (1932).

15. Wright Biography, 35.

16. "American Modern—Furniture Designed by Russel Wright for Conant Ball Company," marketing material, ca. 1935, 1, Wright Archive. Italics in original.

17. Ibid., 2.

18. Hennessey, *Russel Wright*, 35.

19. The fluid shapes in Arp's canvasses of the early 1930s, according to art historian H. W. Janson, "have their own vigorous life. They seem to change before our eyes, expanding and contracting like amoebas until they approach human individuality closely enough to please the artist." (H. W. Janson, *History of Art*, 4th ed. [New York: Harry N. Abrams, 1991], 732.)

20. "Resting Your Skis…Designed by Russel Wright" *Esquire* (January 1939), 80.

21. Comparing the outdoor living room to the Art Deco–inspired room Russel designed for the Metropolitan Museum in 1933 vividly underscores his aesthetic transformation.

22. Wright Biography, 35. Wright's other assignments at the Fair included *The New York Department Store* exhibit, *The Fashion Show* exhibit, and displays for Guinness Stout and the National Committee of Mental Hygiene.

23. The photograph was published in the September 15, 1937, issue of Harper's Bazaar.

24. "American Way" marketing materials, January 1941, 2, Wright Archive.

25. Press release, ca. 1940, Museum of Modern Art, Architecture and Design Study Center files. Donald Deskey's "Sportshack," presented at the same World's Fair and at the 1940 industrial design exhibition at the Metropolitan Museum of Art, is a less rugged, prefabricated version of a similar idea.

26. "Living in a Laboratory," Interiors (June 1943), 31.

27. Ibid.

28. Russel and Mary Wright, "Bedroom," Architectural Forum (September 1942), 128–29.

29. John Normile and Bob Gilmore, "How Will You Live Tomorrow?," Better Homes and Gardens (September 1944), 15.

30. Nelson and Wright introduced the "storagewall" concept in the November 1944 issue of Architectural Forum. They also published the idea in their 1945 book Tomorow's House: The Complete Guide for the Home-Builder and in the January 22, 1945, issue of Life magazine.

31. Defining the American character was the subject of such contemporary books as The American Mind: An Interpretation of American Thought and Character Since the 1880s (1950) by Henry Steele Commager; The Lonely Crowd: A Study of the Changing American Character (1950) by David Riesman with Nathan Glazer and Reuel Denney; and People of Plenty: Economic Abundance and the American Character (1954) by David Potter.

32. B. F. Skinner, Walden Two (1948; reprint, New York: Macmillan, 1962), 72.

33. Frances Heard, "What Is the Station Wagon Way of Life?" House Beautiful (June 1952), 104–9.

34. Russel and Mary Wright, Guide to Easier Living (New York: Simon and Schuster, 1950), 5.

35. Ibid., 1.

36. Ibid.

37. Ibid., 6.

38. Wright Biography, 9, in the section on Cambodia. The temple was Ta Prom.

39. "A Letter from Russel Wright to All Those Working on the House," unpublished typescript, n.d., n.p., Manitoga.

40. Wright, "Garrison Slide Lecture."

41. Doris Lockhart Saatchi, "Dragon Rock after Life," Nest, Summer 2000, 175.

42. Wright, "Garrison Slide Lecture."

43. Ibid. and Wright Biography. Wright's discussion of the harem suggests his interest in the Far East, which deeply influenced the design of Dragon Rock. In 1955, while planning the house, Wright accepted an invitation from the State Department to tour Japan, Hong Kong, Thailand, Cambodia, and Vietnam in order to study and recommend ways to increase exports of Asian handicrafts to the United States. Wright's diaries during the two-month trip record his impressions of the inadequacy of the Japanese household's mechanical systems and Asia's foolhardy attempts to imitate Western-style period furniture. Also railing against the "unemotional International Style" being practiced in the West, Wright is enthralled with the warmth and craftsmanship of the Japanese home and the visually stimulating contrasts in Asia between old and new.

44. Wright, "Garrison Slide Lecture."

45. Ann Wright, interview with author, November 2000.

46. "A Wonderful House to Live In," Life (March 16, 1962), 74–83.

47. Ann Wright, interview with author, November 2000.

48. "A Letter from Russel Wright to All Those Working on the House."

49. Ann Wright, interview with author, November 2000.

MANITOGA

1. "A Letter from Russel Wright to All Those Working on the House," unpublished typescript, n.d., n.p., Manitoga.

2. Russel Wright, "A Garden of Woodland Paths" (written 1970; published by Manitoga, 1999), 1.

3. Wright, "A Garden of Woodland Paths," 1; "Conservation," typescript, 1969, n.p., Manitoga.

4. Wright, "A Garden of Woodland Paths," 5.

5. "A Letter from Russel Wright to All Those Working on the House."

6. Wright Tapes.

7. Wright, "A Garden of Woodland Paths," 1.

MARKETING EASIER LIVING

1. Russel Wright, "Mechanisms of Magic/Hard Work of Industrial Design," typescript of speech given at the Philadelphia Art Alliance, 1938, 3, Wright Archive.

2. "About the House," The New Yorker, September 17, 1949, Wright Archive.

3. Quoted in Mary Ryan, letter to Russel Wright, August 8, 1934, Wright Archive.

4. Wright Tapes.

5. Wright Tapes.

6. Ann Wright, interview with author, n.d.

7. Mary Wright, "The New American Etiquette," typescript, ca. 1933, 2, Wright Archive.

8. Ibid.

9. Wright Tapes.

10. "Scrapbook," Oversize 25, Wright Archive.

11. Wright Tapes. Wright recalled that he "quickly rebelled against imported design" and "abstained from looking at European magazines." He "tried consciously to develop American products [that would] appeal to contemporary Americans."

12. Wright Tapes.

13. Mary Ryan, "Memorandum on the Russel Wright Line," n.d., Wright Archive. Italics in original.

14. His demand was mentioned in a letter from Mary Ryan to Russel Wright, August 17, 1934, Wright Archive. Mary Ryan responded, "We regret we cannot agree with you." And that was that.

15. Wright Tapes.

16. Ironically, the Paris Exposition has recently been viewed as more historicist than avant-garde. See Judith B. Gura, "Modernism and the 1925 Paris Exposition," Antiques (August 2000), 194–203.

17. Catalogue, "Scrapbook," Oversize 25, Wright Archive.

18. Ibid.

19. Clipping, "Scrapbook," Oversize 25, Wright Archive.

20. O. L. Overby, "Statement," n.d., Wright Archive.

21. Mary Wright, "What Is Swedish Modern?," typescript, 4, Wright Archive.

22. Wright Tapes.

23. Contract, July 1, 1936, 9, Wright Archive.

24. Financial statement prepared by Frederick Fromholz, "as per books," December 31, 1936, Wright Archive.

25. Wright Tapes.

26. Irving Richards, interview with author, January 1996.

27. Tearsheet, "Scrapbook," Oversize 25, Wright Archive.

28. Mary Wright, "The New American Etiquette," typescript, circa 1933, 1, Wright Archive.

29. Tearsheet, "Scrapbook," Oversize 25, Wright Archive.

30. Wright Tapes.

31. Press release, Wright Archive.

32. Press release, Wright Archive.

33. Jane Watson, "American-Way," Magazine of Art (November 1940), 629.

34. Ibid.

35. Wright Tapes.

36. Contract, December 7, 1940, 1, Wright Archive.

37. Raymor grew into a highly successful company, exclusively distributing such design icons as George Nelson's clocks, Arne Jacobsen's "Ant" chairs, and American Modern dinnerware. In 1963, with sales of $20 million a year, it was sold to Simmons Bedding. In the 1980s, Simmons was bought by Gulf + Western, who liquidated the Raymor subsidiary.

38. Wright Biography, 39.

39. All quoted passages in this paragraph are from the Wright Tapes.

40. On December 9, 1946, Russel and Mary Wright gave such a presentation sponsored by Bloomingdale's at the Sherry Netherland Hotel in New York City, and only one cup broke. Mary Roche, "New Wright China Is Hard to Break," New York Times (December 10, 1946).

41. Press release, Wright Archive.

42. Press release, Wright Archive.

43. Retailing Daily, January 2, 1951. Clipping, Wright Archive.

44. Wright Tapes.

45. The poll was conducted among 1,000 families comprising the Readers-Research Panel. "Scrapbook," Oversize 25, Wright Archive.

SELECTED BIBLIOGRAPHY

Compiled by Kristina Kaufman

"About the House," The New Yorker, September 17, 1949.

Beyer, Glenn, ed. The Cornell Kitchen: Product Design Through Research. Ithaca, N.Y.: Cornell University, 1952.

Brody, Barbara. "Russel Wright's American Modern Furniture: Out of Yesterday Comes Tomorrow." Unpublished master's thesis, institution not specified, 1984. Courtesy Ann Wright.

"Building a Dream House: The Story of Dragon Rock." Russel Wright Papers, Department of Special Collections, Syracuse University Library.

Cheney, Sheldon, and Martha Candler Cheney. Art and the Machine: An Account of Industrial Design in 20th-Century America. New York: Whittlesey House, 1936; reprinted, Acanthus Press, 1992.

Cochrane, Diane. "Designer for All Seasons." Industrial Design, March–April 1976: 46–51.

"Conant Ball Co. Introduces 'American Modern,' Designed by Russel Wright," marketing brochure, 1935. Russel Wright Papers, Department of Special Collections, Syracuse University Library.

Craig, Hazel Thompson, and Ola Day Rush. Home with Character. Boston: D. C. Heath, 1952.

"Design Concept In Color." Interior Design, April 1966: 194–97.

"A Designer at Home." House Beautiful, April 1934: 30–33.

Eidelberg, Martin, ed. Design 1935–1965: What Modern Was. Montreal: Le Musée des Arts Décoratifs de Montréal, 1991.

———. Eva Zeisel: Design for Industry. Montreal: Le Château Dufresne and Le Musée des Arts Décoratifs de Montréal, 1984.

Ewen, Stuart. Captains of Consciousness: Advertising and the Social Roots of the Consumer Culture. New York: McGraw-Hill, 1976.

Faber, Manny. "Like a Rock Cast in the Sea." New Republic, November 20, 1944: 661–62.

"The Fear of Change." Interiors, June 1949: 77–86.

"For Resting Your Skis." Esquire, January 1939: 80.

"For Yachting on a Modest Scale." Esquire, August 1939: 88–89.

Gueft, Olga. "Russel Wright's Dragon Rock." Interiors, September 1961: 100–111.

Gura, Judith B. "Modernism and the 1925 Paris Exposition." Antiques, August 2000: 194–203.

Hanks, David, with Jennifer Toher. Donald Deskey: Decorative Designs and Interiors. New York: Dutton, 1987.

Harrison, Molly. The Kitchen in History. New York: Charles Scribner's Sons, 1972.

Harvey, Brett. The Fifties: A Women's Oral History. New York: HarperCollins, 1993.

Heard, Frances. "Modern Gets More Human All the Time." House Beautiful, June 1951: 98–99.

———. "What Is the Station Wagon Way of Life?" House Beautiful, June 1952: 104–9.

Hennessey, William J. Russel Wright: American Designer. Cambridge, Mass.: MIT Press, 1983.

Hofstadter, Dan. "Rock Steady." House Beautiful, November 2000: 182–84.

"A House That Says Made in America." House Beautiful, June 1951: 105–11, 141–42.

"Iroquois China Company press release," undated. Russel Wright Papers, Department of Special Collections, Syracuse University Library.

Johnson, J. Stewart. Alvar Aalto: Furniture and Glass. New York: Museum of Modern Art, 1984.

Kaplan, Michael. "Merchandising Modernity: Raymor." I.D., January–February 1995: 20.

Kaufmann, Edgar, Jr. "Russel Wright: American Designer." Magazine of Art, April 1948: 144–45.

Keller, Joe, and David Ross. Russel Wright Dinnerware, Pottery & More: An Identification and Price Guide. Atglen, Penn.: Schiffer Publishing, 2000.

Kerr, Ann. The Collector's Encyclopedia of Russel Wright Designs. Paducah, Ky.: Collectors Books, 1990.

Leonard, R. L., and C. A. Glassgold, eds. Modern American Design. New York: Acanthus Press, 1992.

Levenstein, Harvey. Paradox of Plenty: A Social History of Eating in Modern America. New York: Oxford University Press, 1993.

———. The Transformation of the American Diet. New York: Oxford University Press, 1988.

"Living in a Laboratory." Interiors, June 1943: 30–35.

Lovegren, Sylvia. Fashionable Food: Seven Decades of Food Fads. New York: Macmillan, 1995.

Lynes, Russell. The Domesticated Americans. New York: Harper & Row, 1963.

———. "Russell Lynes Observes: Russel Wright Revisited." Architectural Digest, October 1983: 58–62.

McIntosh, Elaine N. American Food Habits in Historical Perspective. Westport, Conn.: Praeger Publishers, 1995.

"Meet Russel Wright." House Beautiful, May 1945: 79.

"Modern American." House and Garden, September 1935: 58–59.

Nelson, George, and Henry Wright. "The Storagewall." Architectural Forum, November 1944: 83–92.

———. Tomorrow's House: The Complete Guide for the Home-Builder. New York: Simon and Schuster, 1945.

Newman, Carol. "Manitoga." World of Interiors, December 1999: 96–103.

Normile, John, and Bob Gilmore. "How Will You Live Tomorrow?" Better Homes and Gardens, September 1944: 15–17.

Overby, O. L. "Statement," undated. Russel Wright Papers, Department of Special Collections, Syracuse University Library.

Plante, Ellen M. The American Kitchen, 1700 to the Present: From Hearth to Highrise. New York: Facts on File, 1995.

Pulos, Arthur. "Russel Wright: American Designer." American Craft, October–November 1983: 11–13.

Read, Herbert. Arp. London: Thames and Hudson, 1968.

Reif, Rita, "Russel Wright, Pioneer Designer in the Modern Mode, is Dead at 72." New York Times, December 23, 1976.

Roche, Mary. "New Wright China Is Hard to Break." New York Times, December 10, 1946.

"Russel Wright on Adjusting Our Professions to Today's Realities." Interiors, December 1951: 90–105.

Ryan, Mary. "Letter to Russel Wright," August 8, 1934. Russel Wright Papers, Department of Special Collections, Syracuse University Library.

———. "Letter to Russel Wright," August 17, 1934. Russel Wright Papers, Department of Special Collections, Syracuse University Library.

———. "Memorandum on the Russel Wright Line." Russel Wright Papers, Department of Special Collections, Syracuse University Library.

Saatchi, Doris Lockhart. "Dragon Rock after Life." Nest, Summer 2000: 162–77.

"Snapshots: Russel and Mary Wright." Interiors, December 1944: 56.

Statton Furniture Manufacturing Company. "What Is Easier Living" sales brochure, ca. 1950. Russel Wright Papers, Department of Special Collections, Syracuse University Library.

Stephens, Alice. Biographical résumé of Mary Wright (unpublished).

Streamlining America. Dearborn, Mich.: Henry Ford Museum & Greenfield Village, 1986.

Venable, Charles L., et al. China and Glass in America, 1880–1980: From Tabletop to TV Tray. Dallas: Dallas Museum of Art, 2000.

"A Wonderful House to Live In." Life, March 16, 1962: 74–83.

"Wright Biography." (Unpublished, in possession of Russel and Mary Wright's daughter, Ann Wright, written 1951–55.)

Wright, Mary. "The New American Etiquette." Typescript, circa 1933, Russel Wright Papers, Department of Special Collections, Syracuse University Library.

———. "What Is Swedish Modern?" Typescript, n.d., Russel Wright Papers, Department of Special Collections, Syracuse University Library.

Wright, Russel. "Bedroom." Architectural Forum, September 1942: 128–29.

———. "Bedroom Comfort." House and Garden, April 1938: 108–10.

———. "Change the Scene with Accessories." Living for Young Homemakers, February 1954.

———. "A Garden of Woodland Paths." Written 1970. Garrison, N.Y.: Manitoga, 1999.

———. "Garrison Slide Lecture." Unpublished typescript. April 1961. Russel Wright Papers, Department of Special Collections, Syracuse University Library.

———. "Mechanisms of Magic/Hard Work of Industrial Design." Unpublished typescript of speech given at the Philadelphia Art Alliance, 1938. Russel Wright Papers, Department of Special Collections, Syracuse University Library.

Wright, Russel, Papers. Department of Special Collections, Syracuse University Library.

Wright, Russel, et al. Russel Wright: Good Design Is for Everyone. In His Own Words. Forthcoming.

Wright, Russel, and Mary Wright. Guide to Easier Living. New York: Simon and Schuster, 1950.

PHOTOGRAPHY CREDITS

Page 10
Courtesy Ann Wright

Page 12
Courtesy Ann Wright

Page 13
Courtesy Ann Wright

Page 14
Courtesy Ann Wright
Photographer: Matt Flynn

Page 15
Courtesy Ann Wright

Page 16
Courtesy Ann Wright

Page 17
Courtesy Russel Wright Papers (here-
inafter known as Russel Wright Papers)
Photographer: Basil ca. Levine

Page 18
Collection Charles Alexander
Photographer: Chris Day

Page 19
Courtesy Ann Wright

Page 20
Courtesy Ann Wright

Page 22
Iroquois Casual China carafes: manufac-
tured by Iroquois China Company;
collection Dennis Mykytyn
Tablecloth in Harvest, rayon and cotton,
1950: manufactured by Simtex Mills;
collection Tom O'Brien
Photographer: Anita Calero

Page 24
Iroquois Casual China gravy bowl,
whiteware: manufactured by Iroquois
China Company; collection Charles
Alexander
American Modern ramekin with lid and
coffee cup with cover, earthenware,
1939: manufactured by Steubenville
Pottery; collection Charles Alexander
Photographer: Chris Day

Page 25
Manufactured by Chase Brass
Collection Cooper-Hewitt, National
Design Museum, 1991-59-116-a/f
Photographer: Matt Flynn

Pages 26 and 27
Courtesy Russel Wright Papers

Page 28
Informal Serving Accessories relish
rosette, spun aluminum, early 1930s:
manufactured by Wright Accessories;
anonymous collection
Oceana rosette, wood, 1935: manufac-
tured by Klise Woodenware; collection
Dennis Mykytyn
Photographer: Matt Flynn

Page 29
Courtesy Russel Wright Papers

Page 30
Collection Charles Alexander
Photographer: Chris Day

Pages 32 and 33
Courtesy Russel Wright Papers
Photographer: Matt Flynn

Page 34
Courtesy Ann Wright
Photographer: Matt Flynn

Pages 36 and 37
Courtesy Russel Wright Papers
Photographer: Matt Flynn

Page 38
Manufactured by Paden City Pottery
Collection Charles Alexander
Photographer: Chris Day

Page 39
Manufactured by Sterling China
Company
Collection Dennis Mykytyn
Photographer: Matt Flynn

Pages 40 and 41
Courtesy Russel Wright Papers
Photographer: Matt Flynn

Page 42
Manufactured by Red Wing Pottery
Collection Cooper-Hewitt, National
Design Museum, Museum purchase
from Charles E. Sampson Memorial
Fund, 2000-24-1,2-a/b
Photographer: Matt Flynn

Pages 43–46
Illustrations from Guide to Easier Living,
1950
Illustrator: James Kingsland
Photographer: Matt Flynn

Page 48
Manufactured by Paden City Pottery
Collection Dennis Mykytyn
Photographer: Anita Calero

Page 49
Manufactured by Paden City Pottery
Collection Charles Alexander
Photographer: Christopher Day

Page 50
Manufactured by John Hull Cutlery
Collection Cooper-Hewitt, National
Design Museum, 1976-15-4-a
Photographer: Matt Flynn

Page 51
Collection Cooper-Hewitt, National
Design Museum, Gift of Russel
Wright, 1976-15-9
Photographer: Ken Pelka

Page 52
Residential dinnerware, melamine
plastic, 1953: manufactured by
Northern Industrial Chemical; collec-
tion Cooper-Hewitt, National Design
Museum, 1991-30-47-a, b; 1991-30-54
Highlight/Pinch flatware, stainless steel,
1953: manufactured by John Hull
Cutlery; collection Cooper-Hewitt,
National Design Museum,
1976-15-4-a/e
Photographer: Matt Flynn

Page 53
Courtesy Russel Wright Papers
Photographer: Matt Flynn

Pages 54 and 55
Courtesy Russel Wright Papers
Photographer: Matt Flynn

Page 56
Courtesy Russel Wright Papers
Photographer: Matt Flynn

Page 57
Residential dinner plate, melamine
plastic, 1953; manufactured by
Northern Industrial Chemical;
collection Cooper-Hewitt, National
Design Museum, 1991-30-54
Samsonite folding outdoor chair, wood
and metal, ca. 1950; manufactured by
Samsonite; collection Cooper-Hewitt,
National Design Museum, 1976-15-3
Photographer: Matt Flynn

Pages 58 and 59
Courtesy Russel Wright Papers
Photographer: Matt Flynn

Page 60
Collection Charles Alexander
Photographer: Chris Day

Page 61
Manufactured by Northern Industrial
 Chemical
Collection Cooper-Hewitt, National
 Design Museum, 1991-30-53
Photographer: Matt Flynn

Page 62
Courtesy Russel Wright Papers
Photographer: Matt Flynn

Page 63
Courtesy Russel Wright Papers

Page 64
American Modern teapot, earthenware;
 manufactured by Steubenville Pottery;
 collection Charles Alexander
Iroquois Casual China teapot, white-
 ware: manufactured by Iroquois
 China Company; collection Charles
 Alexander
Esquire teapot, earthenware: manufac-
 tured by Edwin M. Knowles Pottery
 Company; collection Charles
 Alexander
Photographer: Chris Day

Page 65
Manufactured by Yamato
 Collection Cooper-Hewitt, National
 Design Museum, 1991-30-14-c,
 -15-l, -16-r
Photographer: Matt Flynn

Page 66
Esquire platter in Grass, earthenware,
 1956: manufactured by Edwin M.
 Knowles Pottery Company; anony-
 mous collection
Columbian wooden bowl: collection
 Anita Calero
Photographer: Anita Calero

Pages 68–69
Oceana snail relish and centerpiece,
 wood, 1935: manufactured by Klise
 Woodenware; collection Dennis
 Mykytyn

Informal Serving Accessories sherry
 pitcher, cocktail set, and bottle cooler,
 spun aluminum, early 1930s: manufac-
 tured by Wright Accessories; anony-
 mous collection (sherry pitcher and
 bottle cooler); collection Dennis
 Mykytyn (cocktail set)
Photographer: Anita Calero

Pages 70–71
Bauer ensemble, earthenware, 1945:
 manufactured by Bauer Pottery;
 collection Dennis Mykytyn
Table designed by Charlotte Perriand,
 19th-century English bedspread,
 Japanese food storage boxes,
 and stool: collection Anita Calero
Photograph: Anita Calero

Page 72
Home Decorators covered bowl, plastic,
 1950s: manufactured by Home
 Decorators Company; anonymous
 collection
White Clover covered casserole in
 Golden Spice and sugar bowl in
 Charcoal, earthenware, 1951: manufac-
 tured by Harker Pottery Company;
 collection McKinley Williams (casse-
 role); collection Dennis Mykytyn
 (sugar bowl)
Iroquois Casual China coffee pot in
 Avocado Yellow and covered pitcher in
 Charcoal, whiteware, 1946: manufac-
 tured by Iroquois China Company;
 collection Dennis Mykytyn
Sterling coffee bottle and teapot in Ivy
 Green, earthenware, 1948: manufac-
 tured by Sterling China Company;
 collection Dennis Mykytyn
Photographer: Anita Calero

Page 73
American Modern hostess plate in
 Chartreuse and cup in Black Chutney,
 earthenware, 1939: manufactured by
 Steubenville Pottery; collection Dennis
 Mykytyn
Highlight/Pinch spoon, stainless steel,
 1951: manufactured by John Hull
 Cutlery; collection Jaye Zimet
Matkins in Seafoam and Chartreuse,
 rayon and cotton, 1950: manufactured
 by Simtex Mills; collection Tom
 O'Brien
Stool designed by George Nakashima:
 collection Anita Calero
Photographer: Anita Calero

Pages 74–75
Cooperative table setting from Guide to
 Easier Living
White Clover dinnerware in assorted
 colors, earthenware, 1951: manufac-
 tured by Harker Pottery Company;
 collection McKinley Williams
American Modern tumblers in
 Chartreuse, glass, 1951: manufactured
 by Morgantown Glass Guild;
 collection Dennis Mykytyn
Highlight/Pinch flatware, stainless steel,
 1951: manufactured by John Hull
 Cutlery; collection Jaye Zimet
Matkins in Chartreuse, rayon and
 cotton, 1950: manufactured by Simtex
 Mills; collection Tom O'Brien
Bread board and knife, wood and metal:
 collection Anita Calero
Photographer: Anita Calero

Pages 76–77
Iroquois Casual China buffet
Iroquois Casual China dinner plates,
 redesigned butter dish, divided
 casserole, redesigned pitcher, platter,
 redesigned sugar bowls, cups and
 saucers, and fry pan, whiteware, 1946:
 manufactured by Iroquois China
 Company; collection Dennis Mykytyn
 (except fry pan: collection Anita
 Calero)
Bauer ceramic candlesticks, earthen-
 ware, 1945: manufactured by Bauer
 Pottery; collection Dennis Mykytyn
Highlight/Pinch flatware, stainless steel,
 1951: manufactured by John Hull
 Cutlery; collection Jaye Zimet
Wooden plateau, tray, antique scotch
 bottle, and table: collection Anita
 Calero
Photographer: Anita Calero

Page 78
Country Gardens sugar bowl with spoon
 lid, creamer, and tray, earthenware,
 designed by Mary Wright, 1946:
 manufactured by Bauer Pottery;
 collection Dennis Mykytyn
Upholstery fabric from Easier Living
 chair, probably cotton, ca. 1950:
 manufactured for Statton Furniture
 Company; collection John Shriver
Photographer: Anita Calero

INDEX

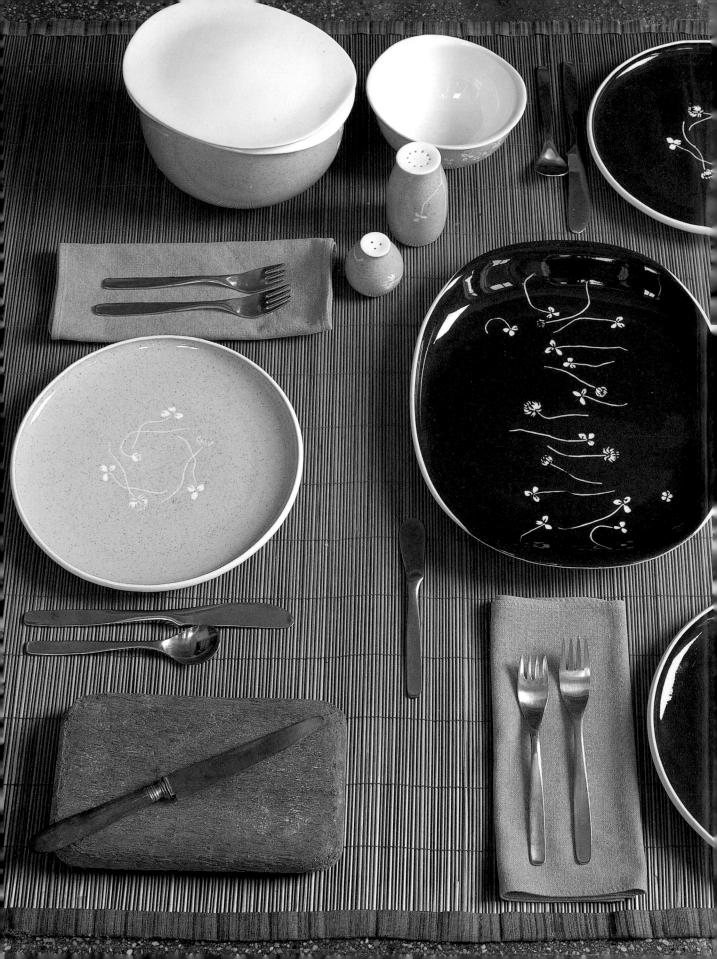